Photographing People

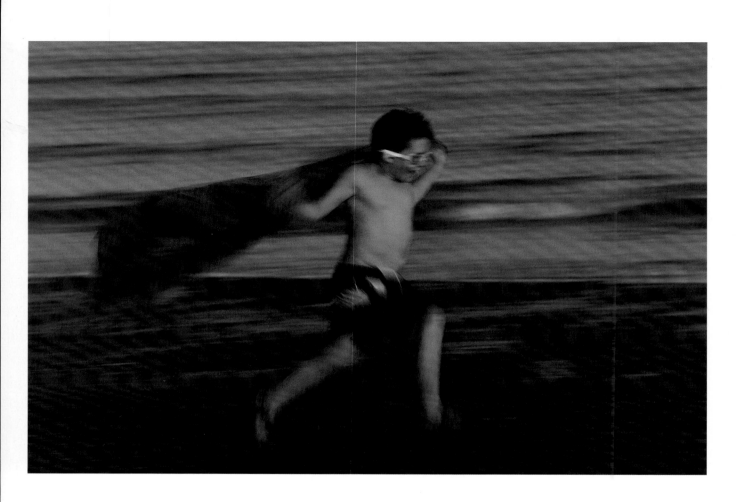

Photographing People

AT HOME AND AROUND THE WORLD

André Gallant

KEY PORTER BOOKS

To my nieces and nephews—Ben, James, Vicky, Joey, Yannick, Sharon and Lisa—thank you
for letting me photograph you all these years.

Library and Archives Canada Cataloguing in Publication

Gallant, André

 Photographing people : at home and around the world / André Gallant ; with a foreword by Freeman Patterson.

ISBN 1-55263-694-1

1. Portrait photography. I. Title.

TR575.G34 2005 778.9'2 C2005-902748-7

The publisher gratefully acknowledges the support of the Canada Council for the Arts and the Ontario Arts Council for its publishing program. We acknowledge the support of the Government of Ontario through the Ontario Media Development Corporation's Ontario Book Initiative.

We acknowledge the financial support of the Government of Canada through the Book Publishing Industry Development Program (BPIDP) for our publishing activities.

Key Porter Books Limited
Six Adelaide Street East, Tenth Floor
Toronto, Ontario
Canada M5C 1H6

www.keyporter.com

Design: Counterpunch/Peter Ross
Electronic formatting: Jean Lightfoot Peters

Printed and bound in Canada

05 06 07 08 09 5 4 3 2 1

Contents

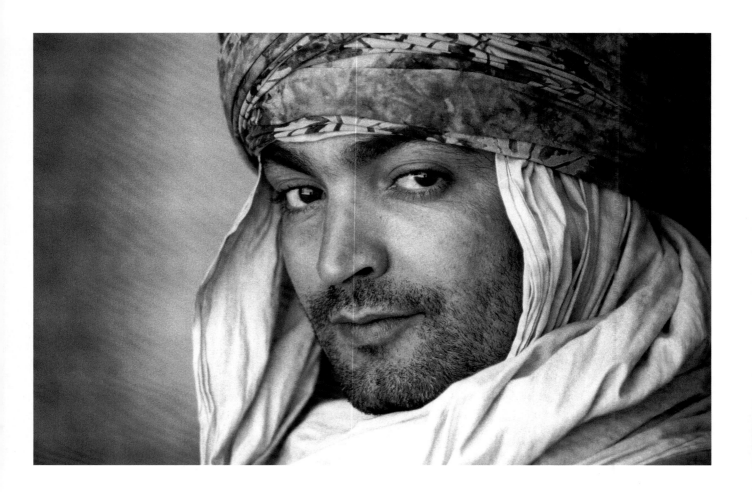

Foreword

André Gallant has been my teaching partner for nearly ten years. Every year we conduct seven week-long workshops together on photography and visual design. Although we hold these workshops in our home province of New Brunswick, Canada, we also teach separately, but regularly, in other countries around the globe. But let me go back.

I conducted my first week-long workshop in 1973 and, after teaching several weeks a year for three years, I was asked to create an instructional book, *Photography for the Joy of it*, which was first published in 1977. Two more instructional books followed in fairly rapid succession: *Photography and the Art of Seeing* in 1979 and *Photography of Natural Things* in 1982. Then, after leading more than a hundred additional workshops over twelve years, I decided to write and illustrate a book based primarily on the main workshop content, which had evolved considerably during that period of time. This book, *Photographing the World Around You*, was published in 1994 and, like its predecessors, continues to be regularly updated and reprinted.

When I first asked André to join me in the workshops, I was confident that he would be a first-class instructor, a teacher who would respect the intelligence of our students and provide them with solid information in a helpful, caring manner. Very soon I realized that I had underestimated both the man and his work, espe-

cially his capacity to grow visually and intellectually. Neither did I fully anticipate the pleasure he would find in working with workshop participants, nor their enjoyment of him.

As a result of our easy, mutually beneficial working relationship and our friendship, I asked André to join me in authoring *Photo Impressionism and the Subjective Image*, an instructional text on multiple exposure, montage and other ideas and techniques for creating impressionistic images. This book was released in the autumn of 2001.

Now André has created the sixth book in this series, *Photographing People at Home and Around the World*, and I am extremely pleased both for him and for you. He is superbly qualified for this project because of his experience with making pictures of people of all ages in many different countries and situations. You will find that his compelling photographs and instructive, often entertaining text will stimulate you to make better, more interesting images of your own family, friends and neighbours, the people you meet while travelling, and even complete strangers. And, equally important, André's pictures and words will provide you with the practical guidance and advice to accomplish this goal.

Freeman Patterson
Shamper's Bluff, New Brunswick
August 2005

Preface

With this book, I want to share the joys of photographing people. Of capturing on film the vulnerability of an infant, the spontaneous actions of a toddler, the tenderness of a loving parent, the wisdom in an elderly gaze. Of photographing the relatives and friends you love dearly, and the strangers you meet in your travels. These are precious moments for a photographer, and sharing them makes it that much more special.

When I bought my first camera, I had no idea how much of an impact it would have on my life. I started photographing nature as a hobby. I felt serene as I took pictures of lakes and rivers, mist in meadows and flowers dancing on windswept mornings. I was quite shy at the time and refrained from photographing people.

Then, on a spring day in 1983, I asked my brother if I could photograph his children, James, Vicky and Ben, who were six, four and three. My first attempt was disastrous, or so I thought. I took James and Vicky to the corner store and bought each of them an ice cream cone. I began taking photographs, and Vicky dropped her cone. She became agitated and tried to take her brother's cone. I tried to calm her down, only to make matters worse. (You do not tell a four-year-old what to do!) I came home very disappointed—nothing had gone as planned.

Later, when I processed the film and looked at the contact sheet, two images stood out. The first was of Vicky, jumping all over her brother, trying to steal his ice cream cone. The second was of James, begrudgingly sharing his treat with his younger sister. To this day,

these are my all-time favourite photographs. They also were my introduction to photographing people.

I spent the rest of the summer photographing my niece and nephews. Ben, the youngest, was very spontaneous and enjoyed posing for the camera. He knew very well that most photo sessions ended with a trip to buy a new action figure or a delicious treat. With the help of these kids, I gradually started to overcome my reluctance to photograph people. Before long, I began photographing my friends' children, selecting interesting locales or backgrounds, finding the right props and hoping that magic would unfold. While I was building my portfolio and learning about light, posing techniques and how to relate to kids, I always gave the parents a set of prints.

Next, I began photographing aspiring local actors and models. They would pose for me in exchange for a few prints for their portfolios. I usually photographed in black and white, processed the film myself and printed my own photographs. I hooked up with a hairstylist and makeup artist and, when word of my photography began to spread, I was asked to photograph local fashion shows, sporting events and, eventually, weddings and commissioned portraits.

I began to feel at ease photographing people I knew. Now I had to learn to photograph strangers. By this time, I knew I wanted to be a travel photographer, so my next challenge would be to travel somewhere and get images of the locals. But I was incredibly shy, and on my first few trips I used a long lens to avoid making contact with these strangers. I brought back many pictures

of people walking away, their backs turned to the camera. In these early travel photographs, I rarely had any clear shots of the locals' faces. When a few art directors pointed this out to me, I knew I had to conquer my shyness if I wanted to succeed as a photographer.

On subsequent trips I began to relax, and even to connect with some of the strangers I aimed my camera at. No longer shooting people from afar, I started to produce interesting portraits. I noticed a big change in my travel images and began to feel confident about the work I was producing. My photography soon caught the attention of editors at various magazines, and I started to get assignments travelling abroad. Most of the covers I've earned for travel magazines feature a person's face, and I've realized the importance of portraits to travel photography. When I look back at the work I've done over the years, I can truly say that my portraiture means the most to me.

Photographing People at Home and Around the World is the sixth in a series of instructional photography books by Key Porter. It was made possible with the help of my very good friend and teaching partner of ten years, Freeman Patterson. Thank you, Freeman, for your never-ending generosity, for making this project happen and for writing the foreword.

André Gallant
Saint John, New Brunswick
August 2005

CAMERAS, LIGHT, ACTION

Portraits are about emotions, character, strength and vulnerability, but they're also about light, composition, posing and surroundings. Before you start shooting, take some time to visualize how you want the resulting photographs to look. Figure out what direction the natural light is coming from, how you can best make use of it, and whether you need to supplement it with a flash or other lighting equipment. Choose a background for your model and decide whether you want to use props. Think about what angle you want to shoot from: off to one side, slightly above, below?

Most important, know your equipment and make sure you have everything you need close by: fresh rolls of film, a reflector, a light meter if you use one, alternate lenses. The last thing you want is to have to fumble with your gear—your model may lose confidence in you or become self-conscious or impatient.

Planning and organization are key components of good photography, but never forget the value of spontaneity. The great thing about photographing people is that they are unpredictable, and the moments you don't expect often make the best pictures.

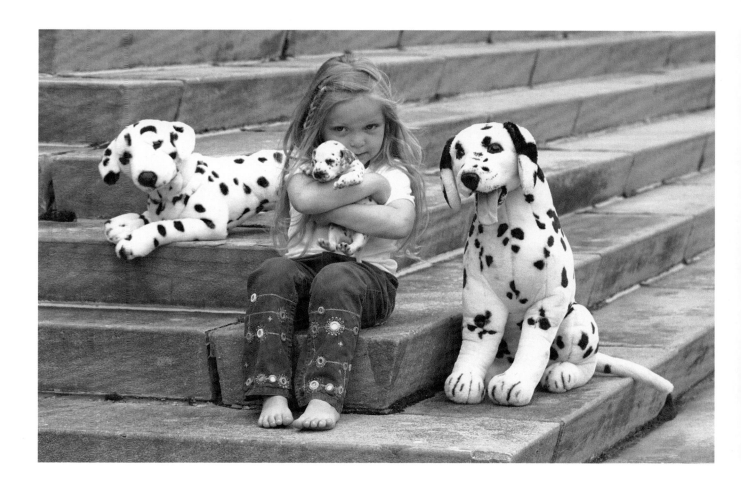

My grand-niece Vanessa was four when Vicky, her mom, asked if I would photograph her. I went over to their place, and we chose her outfit—a pair of jeans and a T-shirt. When I saw all the toy Dalmatians in Vanessa's room, I knew we had to include some of them in the shots. Out of the fifteen or so, I picked two, and off we went to photograph on the cement steps outside, which made for an interesting background. I felt that black-and-white film would work well with the spotted dogs.

It was a bright overcast day with even lighting. I began to photograph Vanessa with her toy dogs, but Vicky and I had a surprise for her. In the middle of the shoot, my niece disappeared for a moment, only to reappear with a live Dalmatian puppy. Vanessa was ecstatic, and she held on to the puppy as if it were her only friend in the world. This was a very happy little girl.

When it comes to choosing the right camera and equipment, you must decide what your needs are as a photographer. As a working professional, my needs are different than, say, those of my neighbour, who wants to photograph at leisure and take snapshots of her children. Because my photographs are used in publications and in advertising, I need the utmost quality a camera—film or digital—can offer. I'm also competing with other professionals, so my work must be at a high level, aesthetically as well as technically. But your needs may be more basic, and a simple, inexpensive camera may suit you well.

The first thing you must decide is whether you want to use film or digital. Over more than twenty years as a photographer, from my beginnings as an amateur until now, I've used film cameras, shooting both negatives and slides, and I've gotten to know film very well. Film is a good choice for me because I use slides to teach my photography workshops. Digital projection is very expensive, and the quality, while constantly improving, does not yet meet with that of slide projection.

I did recently purchase a digital camera (a Canon 20D, which is compatible with all of my lenses), and I'm now exploring this new technology. It's a great tool for photographing people and certainly has some advantages over film. The ability to preview images is one. How many times have I photographed people, on assignment and for myself, and wondered whether I got the image? Was the light right? Did I expose properly? Did the pose look natural? Were the person's eyes closed? With digital, you instantly find out all of the above and, if need be, can make the appropriate changes. You'll never be stuck with a disappointing picture again. If you don't like what you've shot, you can just delete it and try again, as many times as it takes to get the shot you want.

It's also a plus to be able to show the person you're photographing what you're getting and what needs to be improved upon. This is a wonderful icebreaker when you photograph strangers on your travels. Here are some of the other advantages of using a digital camera:

- You'll save on film and processing costs. With digital cameras, pictures are saved onto a memory card, which can be reused over and over again once the images are downloaded to your computer. And good photo printers have come so far down in price that it's cost-efficient and easy to print your own photos at home.
- When you're travelling, you won't have to pack and carry countless rolls of film, as memory cards can hold hundreds of pictures. And you won't have to worry about the effect of airport x-ray machines. It's also great to be able to email images home to family and friends.
- You can experiment at no cost. Trying new techniques such as panning or blurring can be very costly when shooting film, and by the time you see your photographs, you've often forgotten how you achieved the effect. With a digital camera, you can instantly see what results you are getting, then improve each subsequent image until you are satisfied.

35mm SLR film cameras

If you decide to go with a film camera, SLR (single-lens reflex) cameras are ideal for taking pictures of people, as they are fairly simple to use. The camera functions range from fully manual to fully automatic. Although I personally never use autofocus, you may find this function helpful, especially if you're photographing moving subjects, such as kids running and jumping or people engaged in sports.

When it comes to exposure, most SLR film cameras give you the choice of one of the following metering modes:

- *Auto-exposure:* The camera selects both aperture (lens opening) and shutter speed (the amount of time the aperture stays open before the picture is taken). At first, using this mode may liberate you and allow you to concentrate on composition and capturing the right expression from your subject. Once you begin to feel comfortable photographing people, I advise you to pick an exposure setting that will give you more control.
- *Aperture priority:* You select your aperture, and the camera automatically sets the shutter speed according to the light and exposes properly. With a small aperture (f16 or f22), you let less light in and will have more focus throughout your photograph. With a large aperture (f2.8 or f4), you let more light in and will have less focus throughout your photograph.
- *Shutter priority:* You select the shutter speed, and the camera automatically sets the aperture and exposes properly. You can freeze moving subjects by shooting at a high shutter speed (such as $\frac{1}{250}$th of a second), or create and capture a sense of motion by using a slow shutter speed (in the range of $\frac{1}{15}$th of a second or less).
- *Manual:* You select both aperture and shutter speed. This is my favourite shooting mode because I'm in full control of the camera.

Medium-format film cameras

With the quality of 35mm cameras available today, there is no real need to move up to medium-format. But should you want to upgrade your equipment, medium-format cameras offer better image quality than 35mm cameras. Better quality does, however, come at a price:

the equipment is very expensive, and the cameras and lenses are larger and heavier.

The smallest medium-format camera is the 645, which refers to the negative or transparency size in centimetres: 6 × 4.5 cm. The size of the negative is 2.7 times larger than with 35mm film, so the quality of the images is much improved. The next size up is the 6 × 6 cm camera (also referred to as 2-¼ inches or square-format). One advantage of shooting square images is the ease of cropping in the vertical or horizontal—a feature loved by professionals and the publishing industry (especially magazine art directors). The largest and heaviest model, the 6 × 7 cm, has the largest negative or transparency (4.5 times the size of a 35mm negative or transparency), and therefore offers the best image quality. All of these models take 120 or 220 roll films that, like 35mm films, are offered in negatives or slides with various ISOs.

Film

When photographing people, your choice of film is a very important one. Factors such as available light and the colours of surroundings and clothes may influence your decision. I choose my film well in advance of a shoot, based on whether I intend to photograph indoors or outdoors, what time of day I plan to shoot, what background I am going to use, and whether I'm planning a posed shot or an action shot, among other considerations. As you gain experience, selecting what film to use becomes easier.

Your first decision is between colour and black-and-white film. If you're photographing a portrait in a garden or children playing in autumn leaves, colour film is the obvious choice, because the colours are relevant

to the setting. But colour can detract from a character study by pulling attention away from a person's face to his clothing or the background. With black-and-white film, the eyes and any lines on the face gain prominence. I would definitely choose to photograph an elderly person in black and white.

Another option is to use a chromogenic black-and-white film such as Kodak T400CN or Ilford XP2. These films are processed the same way as colour print film (C41), so most one-hour labs can process them, and you will get back a set of black-and-white photographs printed on colour paper. You can ask the lab to tint your prints in a sepia or blue hue at the time of the processing. To ensure consistent results, have a professional lab handle this type of film, rather than the local grocery store or pharmacy.

The second thing you must decide is what film speed (or ISO rating) to use. The speed you use will affect the outcome of your pictures. Slow films (those with an ISO of 50 or 100), offer saturated colours and a fine grain, but you'll need a good amount of light to expose them. When using slow film, you should place your camera on a tripod and use a cable release so you don't have to worry about camera shake. With fast films (those with an ISO of 400, 800, 1600 or 3200), you can photograph when there is less light, but you'll sacrifice some sharpness, and your colours won't be as vibrant. The grain will also be more noticeable, especially on enlargements. For good sharpness and proper contrast, the safest bet when shooting portraits is to choose a film with an ISO between 100 and 400. When shooting indoors, using window light, and when photographing children outdoors under overcast skies, I favour 400 ISO film. It is sensitive enough to light to give me good

photos in low-light situations, and it allows me to use a faster shutter speed, which makes it possible to freeze action and capture children running and jumping.

Your third choice is between print film and slide film. Print film (negatives) is more forgiving of inaccurate exposure than slide film (transparencies) and handles contrast between brightness and darkness better. Also, with print film you can easily get a double set of prints and offer them to the people you've photographed. If you choose to use slide film, it's often a good idea to take extra shots, varying the exposure, when you are photographing a brighter than average scene or a scene with dominant dark tones. This is called bracketing. Take one shot at the exposure your camera meter suggests is the right one, then take a couple more, gradually overexposing a bright scene or underexposing a dark one. That way, you're more likely to end up with a picture that is exposed correctly.

Fuji and Kodak both offer a line of professional portrait print films. Choose slide films designed to reproduce accurate skin tones, such as Kodak E-100, Fujichrome Astia. Fujichrome Provia 100 F, or Agfachrome RSX 100, or 200. Although I have used them on occasion for photographing people, saturated films such as Kodak E-100VS and Fujichrome Velvia are very contrasty and don't always render skin tones properly, often enhancing red noses and skin blemishes.

Digital SLR cameras

Digital photography is growing in popularity at an astonishing rate. As film sales decline, traditional photographers are beginning to worry about the availability of their favourite films. I was shocked when I heard Kodak was stopping production of slide projectors. Will film go the way of eight-track tapes, or cassettes, or now VHS tapes? Only time will tell. Meanwhile, digital photography is constantly improving. I've yet to stop shooting film, but I've also embraced the new technology.

When choosing a digital camera, the most important thing to consider is the number of megapixels the camera delivers to photos printed from it. Pixels (an abbreviation of "picture element") are the tiny dots that a picture on a computer screen is made up of. The higher the number of pixels, the more information and detail you capture, the better the image quality and the larger you can print the image. Cameras in the 3-megapixel range will produce files large enough for good-quality photos up to 11 × 14 inches (28 × 35 cm). I use a mid-size model that delivers 8 megapixels, producing files large enough for my personal use and that of my stock agencies and clients. With an 8-megapixel camera, the quality of the photos rivals that of images produced from slides or negatives.

Another feature to consider is shutter lag (the time delay between clicking the shutter and taking the photograph), more common on point-and-shoot cameras and low-end SLRs. It's inconceivable to try to shoot candid photographs of people or to capture spontaneous expressions if the picture is not taken as soon as you press the shutter, so look for cameras with a low shutter lag.

When using a digital camera, you have the option of shooting in black-and-white or colour, but the decision is much easier here than when choosing film: it makes good sense to shoot in colour at all times because you can convert to black and white afterwards if desired. With a digital camera, you can select and change your

ISO at will, but keep in mind that, when shooting with a high ISO (or when using long exposures), you may notice noise, the digital version of grain, in your images. Noise can be corrected to a certain extent with photo editing programs, but you will lose sharpness. Another terrific feature of the digital camera is white balance, which allows you to correct the colour of artificial light.

Exposure is as crucial with digital as it is with transparency film. Some people believe they can fix exposure later with a photo editing program, but there's only so much you can do onscreen. You'll get much better pictures if you expose correctly when you're shooting. By using the histogram in the LCD panel, you can assess exposures and make the appropriate adjustments to get more details in your highlights and/or shadows. Advanced camera models have a graph that indicates how much information your exposure contains: the shadow areas are shown on the left of graph; the highlights on the right. This will take time to learn and practise, but it also takes a while to understand proper exposure when using film.

Many cameras allow you to choose what file format to shoot in. JPEGs are often favoured because they take up less storage space. TIFF and RAW formats are slower to process and take up more storage space, but they retain more information, which is essential to making large prints. You can also vary the size of the file when you're shooting. The larger the file size, the better the quality, but the more room the picture will take up on your memory card, so you may have to balance your desired quality with how many pictures you can take before you'll need to download the images to your computer.

Film and digital point-and-shoot cameras

Because of their small size, the quality of the optics and the various range of zoom lenses available, film and digital point-and-shoot cameras have become very popular. If you have even a rudimentary knowledge of light and composition, these cameras, which you can slip into a pocket, will give you wonderful results. The ease of operation makes compact cameras ideal tools for photographing people at various events, such as birthday parties and graduations. With autofocus, auto-exposure, and automatic flash features, it's photography simplified. The automatic functions enable you to concentrate on lighting, posing, composition and getting the right expressions.

A few years ago, I was asked to judge a photo contest for serious amateur photographers. There were hundreds of entries, but the grand-prize winner had photographed his son swimming underwater in a pool, using a plastic waterproof disposable camera. The image was outstanding! I would use such a camera to shoot in the pouring rain rather than risk ruining a camera worth thousands of dollars. This example proves that good photography is not about the equipment, but about the person using it.

Peter, the owner of Applebys, the lab I use for my processing, loaned me a digital point-and-shoot camera so I could give it a try. I went over to my neighbour's house and took a few portraits of the kids in her private daycare. I did not use reflectors or a light meter, but instead concentrated on using only the compact camera. I shot a variety of portraits in different rooms and in different lighting situations. I was very impressed with the quality of the images I snapped with such a tiny camera. The kids enjoyed it, too, and because they could see

their photographs on the preview display, they let me take many more frames of them. Now I understand why these cameras have become so popular.

Here are some features to look for in a point-and-shoot camera—analog or digital:

- *A zoom lens:* This feature allows you to shoot images at focal lengths from wide-angle to telephoto. With the zoom lens set to wide-angle, your subject will be smaller, with a wider field of view. Conversely, with the zoom lens set to telephoto, your subject will be larger and the field of view narrower. The depth of field (the area in which objects in your image appear sharp) is less at the longer range of the zoom, which enables you to shoot portraits with a blurred background. Cameras with a zoom lens are more expensive than compacts with a fixed focal length, but the flexibility is worth the extra cost.
- *Flash with fill capabilities:* With fill flash, the camera's flash output is adjusted so it does not overpower the available natural light but produces just enough light to fill in shadows and produce a desirable catchlight (sparkle) in the eyes. Get into the habit of using fill flash: the results will be more pleasing than when you use full flash. One word of caution: with the small size of point-and-shoot cameras, the flash's location makes it easy to accidentally put your finger over it, so pay special attention when you're holding the camera.
- *Red-eye reduction:* Because the flash is so close to the lens on point-and-shoot cameras, your subject's eyes will often have a red glow in your images. With "red-eye reduction," the flash fires several times before the photograph is taken, causing the subject's irises to contract, which reduces the reflection that causes red eye.
- *Variable shutter speeds:* Found on more expensive models, this feature allows you to freeze action, pan or blur images. Variable shutter speeds also allow you to mix flash and ambient light. For example, if you photograph a person in front of a lit Christmas tree, shooting on automatic, the flash will light your subject and the Christmas tree behind, and the lights on the tree will not be apparent in the image. But if you use the flash in conjunction with a slow shutter speed, with the camera steady on a tripod, the flash will light your subject and the tree, and the slow shutter speed will permit the tree lights to be recorded. (If there are other lights on, they may stray into the photograph as well.)
- *DX coding:* With this feature, the camera automatically sets the ISO of the film you are using.
- *Self-timer:* This feature is very useful when the photographer wants to be included in the picture. There is usually a ten-second delay between the time you press the shutter and the time the photograph is taken.

Choosing a Lens

The right lens for your camera depends on the kind of photograph you want to take. Are you looking for a character study with very little background or are you after an environmental portrait with an indication of where a person lives or works?

With wide-angle lenses in the range of 20mm to 35mm, you can include a lot of the surroundings in a portrait. Photojournalists use them most of the time because they have a story to tell. These smaller lenses

are easy to handhold and have a large range of depth of field. Used at close range, though, these lenses significantly exaggerate what is closest to them, which in a portrait can distort the face.

Lenses in the medium telephoto range (100mm to 200mm) are good choices for portraiture. This range allows you to photograph your subject without distortion. You will also be able to shoot without being too close to the person you're photographing, so your model will not feel intimidated. When shot at a large aperture (between f2.8 and f5.6), these lenses can produce blurred backgrounds, thus reducing or eliminating distractions and allowing the viewer to concentrate on facial features.

Long-range lenses (200mm to 400mm) are a good choice if you're after candid portraits. They are very useful in isolating your subject. However, they don't afford as much depth of field as short lenses and they compress perspective. A tripod is recommended with their use. I own a 100mm–400mm image-stabilized zoom, and I love using it when I travel. I can stand back at a fair, market or parade and shoot inconspicuously, getting a variety of portraits.

When I set out to photograph Justine, I chose to use my medium-format Hasselblad. I feel the square format is very dynamic. I used black-and-white film with the intention of hand-colouring a few prints. In this portrait, the use of line is effective, with the handrail leading the eye towards the subject. The background is simple and does not compete with the young girl. I used a tripod to steady my camera, and an 80mm lens shot at f4. The light was natural and diffused through a large window. Using Marshall oils, I added colour only to the subject.

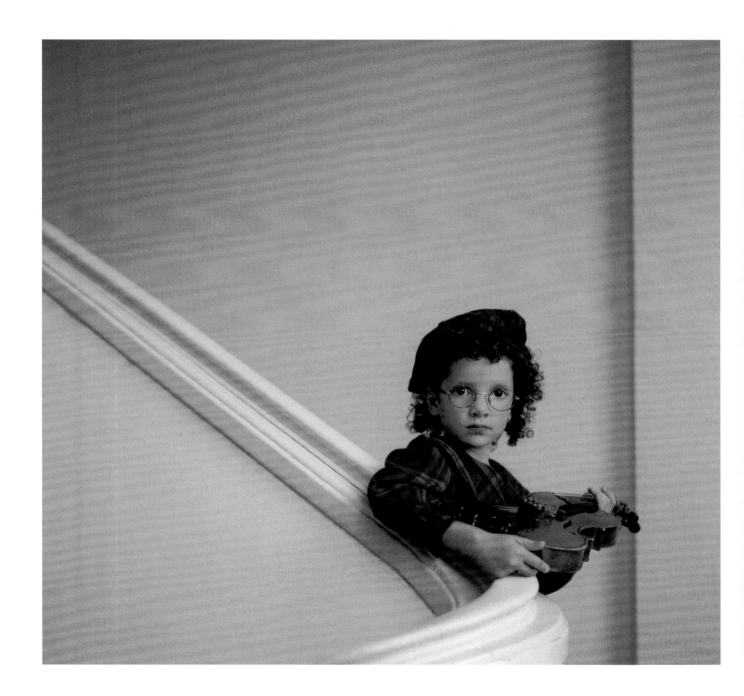

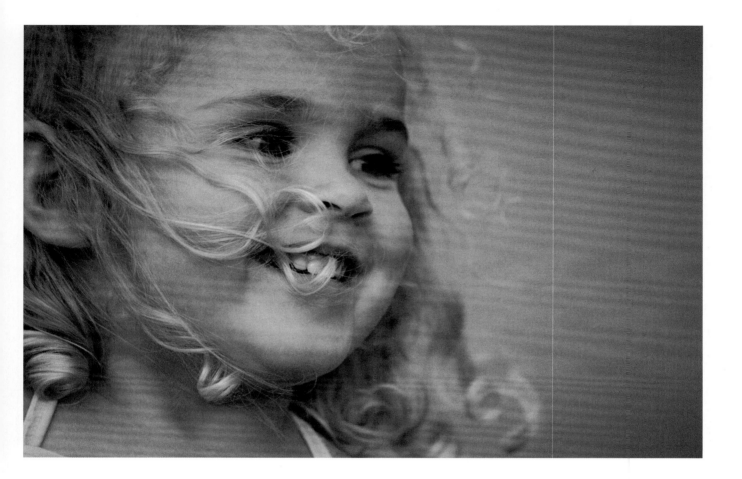

When I set out to photograph Olivia, I had two shots in mind. The first was a panning shot of the child running back and forth between her parents, taking them a small bouquet of wildflowers. I shot a full roll of film, panning at shutter speeds of 1/15th to 1/20th of a second. Afterwards, we headed to the beach, with forty-five minutes left before sunset. By the time we arrived and set up, Olivia's attention span had diminished, and she did not want her picture taken anymore. With the light so beautiful, I was desperate for a few more shots. I asked her father to put her on his shoulders and jump up and down. I was using chromogenic black-and-white film, with an ISO of 400, and shooting at f5.6 with a shutter speed of 1/350th of a second to ensure sharpness. It was difficult to follow her tiny moving face and, out of a full roll of film, I got a lot of photos with parts of the face cut out, but I managed to get this image, which made it all worthwhile.

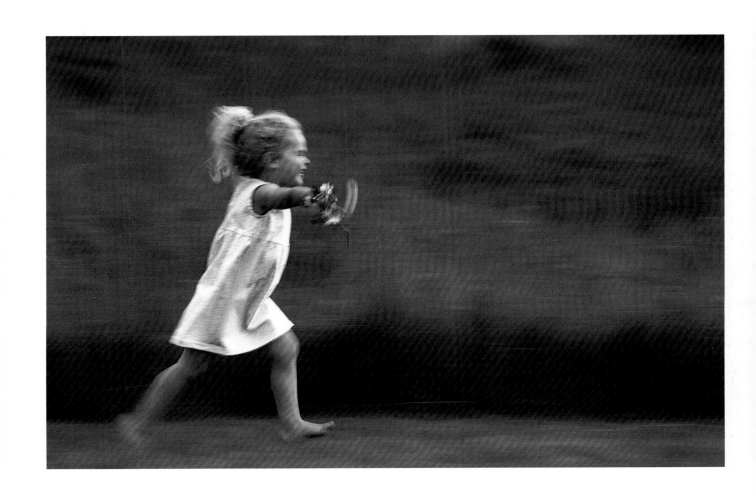

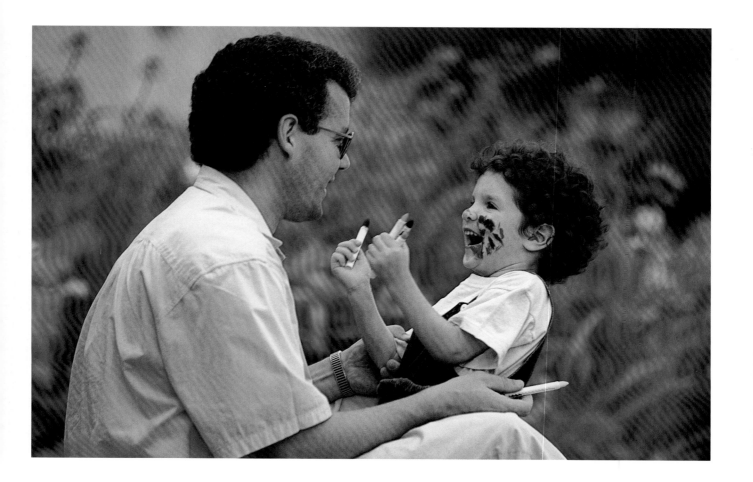

My friend Pierre wanted a photograph with his daughter, and I was more than happy to take one. I went over to their house, and we decided to photograph outdoors. It was a bright cloudy day, which meant soft, even light, no squinting and no high contrast. We did the shoot on their front steps. Because I used my 80mm–200mm zoom lens set at 200mm, I was far enough away not to interfere with their time together, and the garden in the background could be thrown out of focus. Pierre took out face-painting crayons and amused his daughter while I photographed. I like this image because of the spontaneous outburst of laughter.

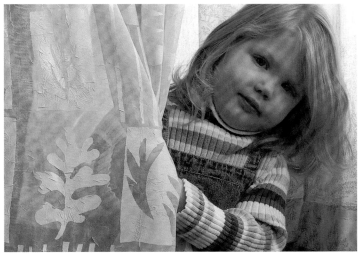

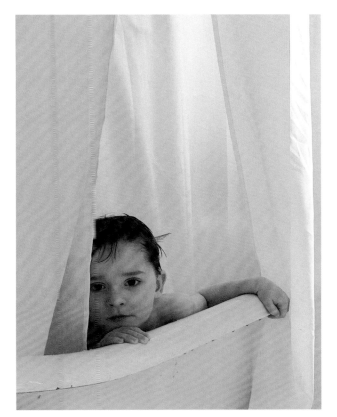

When I photograph the children at my neighbour Michelle's daycare, I m usually burdened with strobes, light stands, a full camera bag and a reflector, and I need to make two or three trips just to bring all my gear over. This time, it was liberating to show up with nothing but a compact digital camera that fit into my shirt pocket. For the next couple of hours, I took individual portraits of the kids in Michelle's care. It was nice to be able to see instantly what I was capturing, erasing the shots that did not work and saving those I was happy with. All of the images on these three pages were taken with a Panasonic Lumix digital point-and-shoot camera (3.1 megapixels). It's an amazing little camera with a 12X optical zoom (equivalent to 35mm–420mm) with full range f2.8 brightness. For the purpose of this exercise, I took all the photos on automatic settings; all I did was point and shoot. Most of the images I shot were sharp, even in low light, because of the optical image stabilizer.

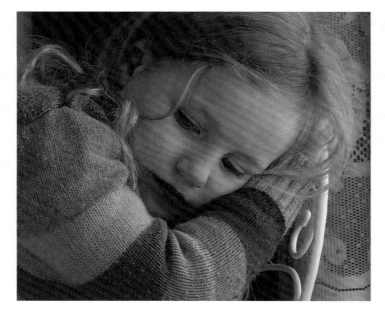

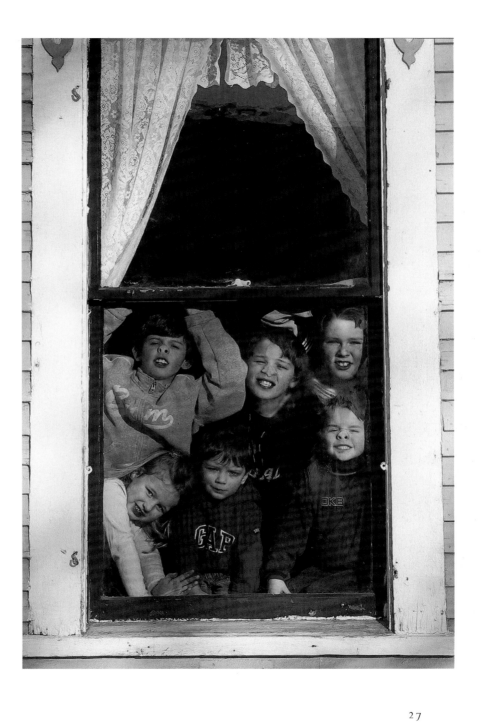

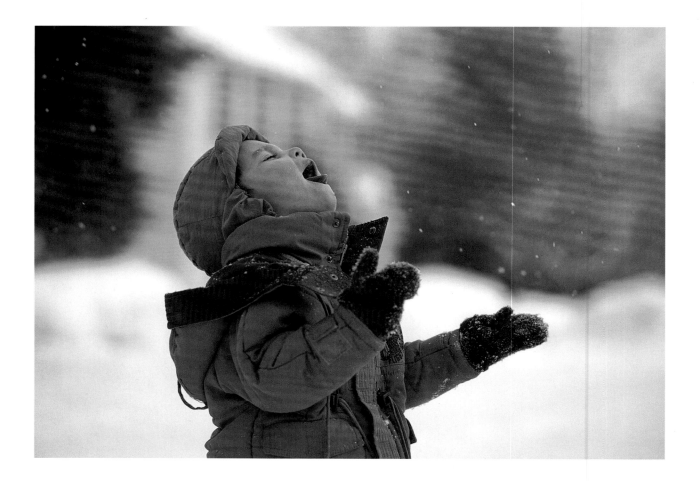

When working on the book *Winter* with Pierre Berton, I was always on the lookout for exciting pictures with snow. On one particular morning, thick snowflakes drifted slowly to the ground. I phoned one of my brothers to ask if his son was avail- able. I wanted to take a few pictures of him playing outside, enjoying the winter. Yannick, who was five at the time, was ready within minutes, and I gathered my gear quickly. I went to pick him up, and we drove to an area in my hometown of Edmundston, New Brunswick, where there are more trees and the houses are older and have some character. I chose to use my 80mm–200mm f2.8 zoom lens because, with slow film (Velvia), this lens enables me to use a shutter speed fast enough to freeze snowflakes in the air. At f2.8, I also get a very nice blurred background. As I photographed my nephew, I asked him to try to catch snowflakes on his tongue. I remember doing that as a child, and this image brings back wonderful memories.

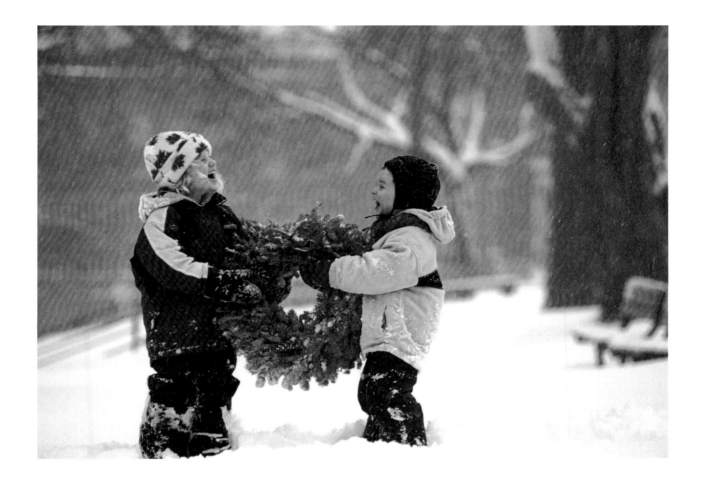

One winter, I wanted to create a fun Christmas image, so I asked Michelle if I could photograph Jaden with Sarah, a child who attends her daycare. She said to let her know when I needed the kids. "When it snows," I said. A few days later, Michelle got the kids ready, dressing them in colourful clothes. I gathered my props (a wreath, fake Christmas presents, colourful scarves) and my camera gear (a tripod, a reflector, a zoom lens and film), and we headed out to nearby Queen's Square. The snow was heavy, and it muted the colours, blanketing the scene in white. Jaden and Sarah, wearing bright colours, stood out against the monochromatic background. I used slide film with an ISO of 100, making sure to overexpose one stop because of all the white in the photograph. This image of the two of them holding the wreath and laughing stood out among the other shots. It seemed less posed, more fun and dynamic.

Light

Light is the most important ingredient in photography, and it can enhance or ruin the outcome of an image. You can improve your pictures by recognizing light's properties—its colour and direction, whether it's diffused (as on a cloudy day) or direct (bright sun)—and using them effectively. This will take some time and practice on your part, but I hope this chapter will get you started and steer you in the right direction.

Early in my career, I showed some of my portraits to a successful and talented photographer. One of his comments about certain images was, "This is beautiful light!" I graciously accepted the compliment, but had no idea what he meant. As I gained more experience, I eventually began to understand light and, better yet, to see its effect in my portraits. Now, after years of practice, I know what beautiful light is.

Available natural light

When you're photographing outdoors, the available light depends on the time of day and the weather conditions. You will discover that the quality of light affects the mood of your photographs. The light of an overcast day is soft and slightly blue in hue, and will convey a gentle mood, while the light on a sunny day is crisp and harsh, giving a portrait a lively quality.

On a clear day, the ideal times to photograph people are just after sunrise and just before sunset. Many photographers refer to those times as the "magic hours" because the light is so beautiful. It is warm in hue, directional and delicate. If you're shooting with a digital camera, make sure you're not set to automatic white balance, which could rid the image of those wonderful warm hues.

When the sun is near the horizon, the light is soft and it's highly unlikely that your subject will need to squint, so you can use front light (when the sun is behind you, the photographer). When the sun's strength becomes unbearable for the eyes, try using sidelight (when the sun falls to the left or right side of the subject), or consider shooting a profile so that your subject is not looking in the direction of the sun. I am partial to backlight (when the sun is behind the subject) for my photographs, and that includes photos of people.

When shooting people at first light, try to include your subject's long shadow in your photographs by using either sidelight or backlight. The key is to be observant and seek out these opportunities.

I love the effect of rim lighting, which is when the sun outlines the human figure, separating the subject from the background. The overall effect is very dramatic. To get a good image with rim lighting, you will need a reflector to bounce light onto your subject; otherwise, you'll have very little detail and the portrait may become more of a silhouette. Fill flash is an alternative to a reflector, but it may not appear as natural, as the light from a flash is cooler in hue than natural light.

As the morning progresses, the sun intensifies, and so will the contrast. With the sun high in the sky, shadows become very dark and fall below the eyes. Photographing people in direct sunlight at midday is a challenge both because they tend to squint and because neither film nor digital images can reproduce the extreme contrast between highlights and shadows. Again, rely on a reflector or fill flash. By adding light to the shadowy areas, these tools will help reduce the contrast. Place the reflector (try the white surface) in front of the subject and adjust the amount of reflected light by moving it closer or farther away. You will notice the effect of the reflector when you angle it near your subject. When you are pleased with what you see, take your shots. If you're using fill flash, adjust its light output to one stop less than your daylight exposure.

Areas in open shade provide a great atmosphere for beautiful photographs. The ideal situation is a shaded spot close to where the sun is shining, such as a gazebo, a bandstand or an open porch. The fill flash or reflector (try the silver/gold combination, if you have one)

should catch enough sunlight to provide sufficient light. Make sure the background of your image is not in full sun, as this can make the light on your subject appear flat and dull.

When it's cloudy, the light is soft and even. The use of a reflector (with the silver surface or the silver/gold combination) will help by adding light to the face. If angled carefully, it will also add a catchlight (a sparkle or bright spot reflected in the eyes) to your portrait. Because the light is cool under a cloudy sky, it's a good time to use an 81A warming filter (an amber glass filter that adds a warm hue to your images). If you haven't used one before, experiment by using it on some of your pictures. You can decide later which images you like best, those with the warm hue or those without.

Window light

Light coming through a window or an open doorway is a wonderful source of illumination for portraits. Many professional photography studios are designed and built with window light in mind, and they often have an array of large windows, usually facing north (in our part of the world) because window light from the north is indirect at all times of the day and of the year. For those of us without a studio, any window in the house can be used. If the sun is low in the sky and streaming in, use a piece of sheer fabric or a professional diffuser such as the Flexfill to diffuse and soften the sun's rays. When the sun is higher up, the light is ideal for photographing people. As the sun moves throughout the day, the intensity, direction and colour of light will constantly change, so it's worth it to experiment and photograph at different times. You can then compare the results and see what you like best.

The size of the window will dictate the kind of portrait you can take. Small windows may allow in only enough light to take head shots, while larger windows may let in enough light to allow you to take head-and-shoulder photographs or even full body shots.

Light through a window or a doorway falls off quickly, and a large reflector can be helpful in filling in shadows on the side farthest from the light source. When I first became serious about photography, but was still working on a meagre budget, I made my own reflectors by covering large wooden boards with aluminum foil. To this day, I still use them, indoors and out. The sturdiness of the board makes it easy to prop the reflector up at an angle, while the weight prevents it from flying off in the wind.

On-camera flash, fill flash and automatic flash units

Light from an on-camera pop-up flash is certainly not flattering in portraiture. It's too directional and harsh, it may cause red eye because of its close proximity to the lens, and it often creates an unwanted shadow behind the person you are photographing. Why is it on most cameras, then? To allow you to get snapshots of family and friends indoors or at night.

As an alternative to using the flash as your main source of light, look through the owner's manual for your camera and find out if there is a setting for fill flash. With fill flash, the flash becomes a supplement to the available light rather than your main light source. Your camera will expose for the available light, and the flash will add enough light to fill in shadow areas, soften the contrast and add a catchlight.

It's not unusual to use fill flash when photographing people outdoors on bright, sunny days. When the sun is high in the sky, people get dark shadows under the eyes and below the nose. If your subject is wearing a hat or baseball cap, a shadow will be cast across the face. Fill flash adds light to the face and fills in those shadows (while softening the contrast) for a more evenly lit photograph. When using fill flash, make sure the flash does not equal or overpower the ambient light. It should be set to one stop less light than the available daylight.

Fill flash is also useful when your subject is backlit. Without it, your subject will appear more as a silhouette. The fill flash opens up the shadows and creates a catchlight in the eyes.

If you want more control and better quality of artificial light, a good automatic flash unit (speedlight or flashgun) compatible with the camera brand you use is a worthwhile investment, especially if you do a lot of portraits. When buying an automatic flash unit, look for these features:

- *Auto-exposure:* The flash unit figures out everything for you.
- *Fill flash:* The flash outputs an amount of light one stop less than the available light.
- *Flash-ready light:* A light that comes on when the unit is fully powered.
- *Bounce capability:* The flash can be positioned to bounce off a ceiling or nearby wall for a softer, more diffused light effect. (Note: the ceiling or wall should be white, otherwise the colour may affect the bounced light).
- *Flash diffuser:* Used to spread light when shooting with a wide-angle lens.
- *Flash exposure confirmation:* A small light that lets you know whether your subject was properly exposed.

- *A long flash synch cord:* Links the flash to the camera and allows you to place it away from the lens (perhaps by holding it higher and slightly to the left or right of the camera), which will improve your flashed photos.

It's important to know the maximum shutter speed at which your camera is synchronized with the flash. This information is available in your camera owner's manual. With older models, the maximum shutter speed can be as slow as 1/60th of a second; if your shutter speed is faster, the camera will not be able to synchronize the flash to the shutter, and you will get only partially exposed photographs.

I must confess I'm still timid about using flash. Like everything else, it takes time and practice to master.

Floodlights

Floodlights are strong tungsten halogen lamps that produce a continuous stream of warm light, allowing you to see exactly how your subject is lit. They are not as popular as strobes, as they produce a lot of heat and, when you use colour film, you need to filter the tungsten light to obtain the proper colour rendition. Tungsten-balanced film (blue filter corrected) is made specifically for photographing with floodlights. (If you shoot with black-and-white film, you don't need to worry about balancing colours.)

Strobes

Studio lights allow you to photograph indoors, replicating daylight while having full control over the lighting. Studio lights are not for everybody, but if you're serious about photography, a strobe system may be a worth-while investment. When I turned pro in the late 1980s, I purchased a setup with four lights, powered by an electrical power pack that delivered 1,600 watts of light—more than enough power to light a person or a small group of people. If you plan to shoot in a studio rather than on location, a strobe system with an electrical power pack may be ideal for you. Such a system delivers a lot of power and can usually feed one to four strobes. You can control the amount of power to suit the ISO you want to shoot at and the depth of field you require. I've been using the same system for the past fifteen years or so. Although I don't use it often, it still meets all my requirements when shooting in the studio. If you plan to do a lot of location work, investigate battery-operated strobes.

Strobe lights should have modelling lamps that allow you to see the effects of the light as you are setting up. The flash heads usually come with a small reflector dish that directs the light and prevents it from spilling into the room. Different sizes are available.

You can also buy single-powered strobe lights called monoblocs, then add to your system when your budget allows or when you find you need more lights. These units synchronize to your camera via a synch chord. They have a built-in modelling lamp, and you can adjust and control the light output by the flash head. Some models come with a built-in slave (a device that sets off the strobe when it senses a burst of light from another source) so you can use other units simultaneously.

It is possible to use only one light (called a key light) effectively in portraiture. Position the key light slightly to one side of the person you're photographing, and high enough so that the nose casts a small shadow above the upper lip. A reflector on the opposite side will

reduce the contrast by adding light to the shadowed area. You can use a second strobe instead of a reflector, but make sure the light output is less than the key light (you don't want to produce a second shadow—there is only one sun in our hemisphere). Additional lights are useful, one to highlight the hair (a hair light) and one to light the background.

Consider purchasing the following accessories, which will give you more control over your strobe lights:

- *Diffusers:* Umbrellas and softboxes are used to soften the harsh light of strobes. They come in a variety of shapes and sizes. Some umbrellas are made of translucent white fabric; the strobe is fired through them. Reflective umbrellas are lined with different finishes (similar to reflectors), with white used for a soft neutral light, silver for a harsher, cooler light and gold or a silver/gold combination for a warmer light. Softboxes are made to emulate window light. Square or rectangular in shape, they come in many different sizes. Beware, as they tend to be bulky and hard to work with in a confined area. Without using as much space, you can replicate the light and look of a softbox by bouncing your strobe off a large piece of white foam board.

- *Barn doors:* This shading device with four moveable flaps fits onto a strobe light and is used to control and shape the light falling on your subject or the background.

- *A snoot:* This elongated tube is used to concentrate light, giving it a spot effect. It's usually used as a hair light or to accent a background.

- *Coloured gels:* These sheets of coloured plastic that act like filters can be used over strobe lights for different effects.

When you decide to invest in a lighting system, the advice of a knowledgeable sales rep in a photo equipment store is invaluable. You might also seek the advice of professional studio photographers.

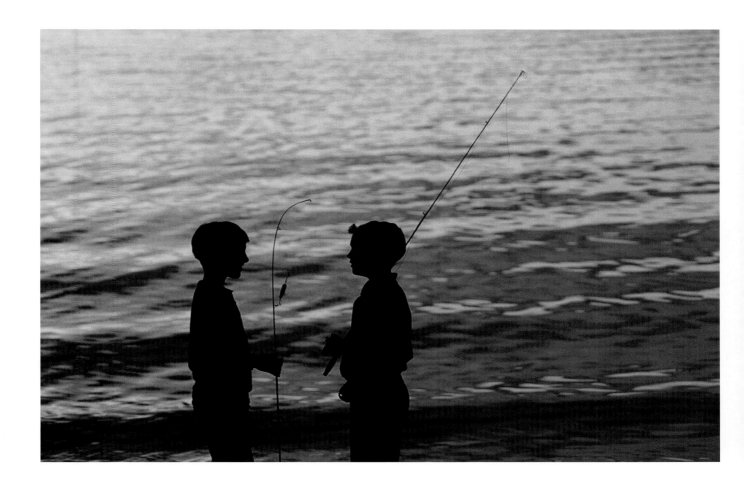

Working on an advertising campaign for Tourism New Brunswick one year, I was taking photographs of two young boys in different situations and surroundings. I shot them fishing by a covered bridge, riding their bikes in the countryside and flying kites on the top of a hill. Near the end of the day, I took them back to their cottage on beautiful Bellisle Bay. When we arrived, the sun had just set, and the colours of the sky were reflected on the lake. In hues of gold, orange, red and blue, the water's reflection was my background in need of a subject. It was nothing less than magical. As quickly as possible, I grabbed my camera and told the boys to get their fishing rods. I asked the boys to walk at water's edge and face each other, then proceeded to take some photographs of the brothers, silhouetted against the colourful mosaic.

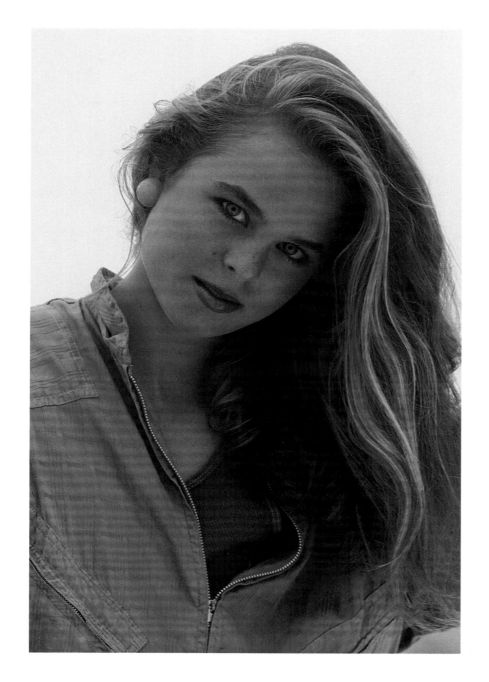

During a workshop, I was photographing aspiring models on the coast of Maine. It was a foggy day, and the light was soft and cool, ideal for photographing people. For this head-and-shoulders portrait of Molly, I set up a reflector at an angle in front of her to bounce light into the shadow areas under her eyes and nose. The reflector also produced a subtle catchlight in those deep blue eyes. The tilt of Molly's head creates a subtle oblique line in the photograph that improves the composition.

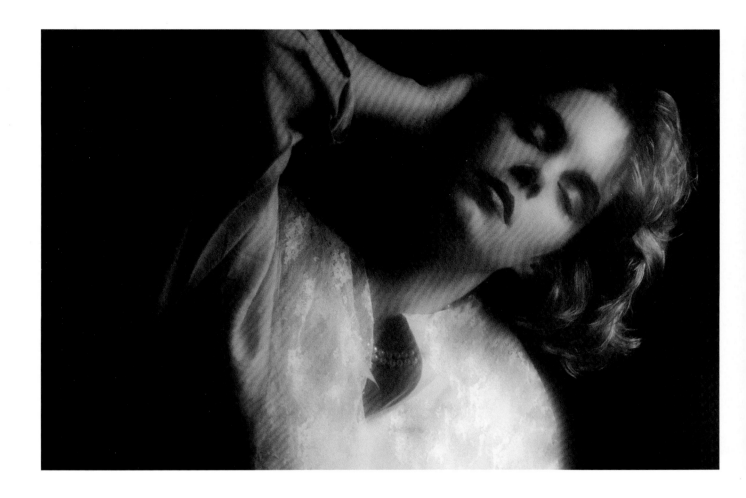

I photographed this aspiring model using window light. Because the sun was low in the sky and streaming in, I used a large piece of opaque plastic to diffuse and soften the light. I used Agfachrome film with an ISO of 200 for its enhanced grain appearance and warm hue. To ensure sharpness, I used a tripod.

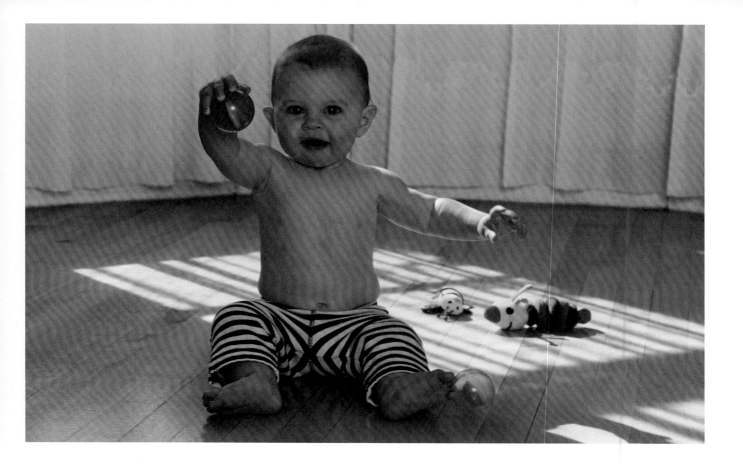

When this photo was taken, Maia was nine months old and at the crawling stage. Her parents, Bruce and Heather, were very excited when I asked to photograph her. They told me that Maia was a very happy baby between 10:00 and 11:30 a.m. Since they live across the street, I asked Heather to call when they were ready.

The call came at about 10:30 the next morning. I walked over with my equipment. Knowing Bruce and Heather's house well, I had decided to photograph in a room with three large windows. I anticipated that morning light would spill into the room, and I brought a strobe, with an umbrella to diffuse its light. As I expected, the sunlight was pouring through the windows and falling on the hardwood floors. I adjusted my strobe to one stop less than ambient light so its light would not overwhelm the natural light.

I asked Heather to stand close behind me so Maia would look straight at us. We changed Maia's clothes several times and finally photographed her in just a diaper. Our little model was all smiles during the photo session. It was a good half hour before she got restless and hungry. I felt good about the shots, and Bruce and Heather were very grateful.

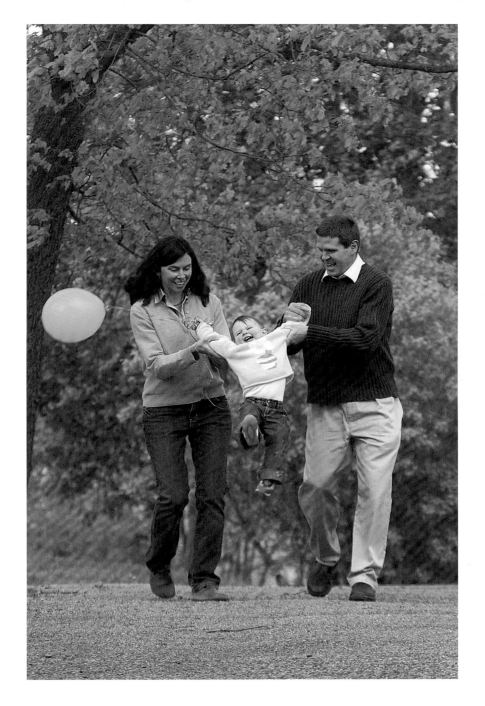

I photographed my friends Bruce and Heather with Maia, thier 18-month-old daughter. I opted for my digital camera because I could see instantly if I was capturing the mood and expressions I was after. As the sky was heavily overcast, I used my flash as fill to make sure their faces (especially the eyes) would be properly lit.

Once you've chosen your camera, film and lenses and decided whether to photograph indoors or out, it's action time. But before you pick up your camera and begin to shoot portraits, you need to think about composition: how to arrange the various components of your picture to create the most pleasing visual design. Your first decision when composing a photograph is what to include and what to leave out. This is a form of cropping (see page 43), but you do it in advance of shooting. Will you include a lot of background, or shoot tight in on your model? Will you photograph only your model's head, or will you include her shoulders or her entire body? Will you be using any props in your portrait? All of these elements will affect the composition of your photograph.

Composition

When composing your image, you'll first need to decide whether to shoot horizontally or vertically. If your subject is standing, it may be easier to fill the frame if you shoot vertically. If you're photographing a group of peo-

ple, or if you want to include a lot of background and create an environmental portrait, you may prefer the horizontal format.

The rule of thirds consists of dividing your viewfinder (or your picture) into three parts vertically and horizontally (see illustration, below). The four points where the lines cross are key places to put your subject or centre of interest. If you're shooting a close-

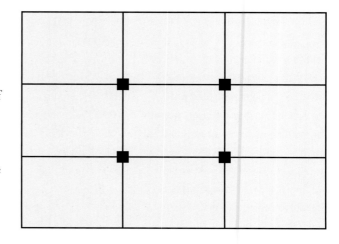

up, consider the rule of thirds when placing the eyes. With a full-body portrait, plan your photograph so that the head falls near one of the two higher points. Leave as much space above the head as below the feet.

Avoid placing your subject dead centre in the photograph, as this may result in a static image. You should also avoid having the horizon cut the picture in half. Give prominence to what is more interesting in your scene. If the sky is incredible, favour it by having very little foreground. When the foreground is beautiful, there might be no reason to include a lot of sky. Often, having no sky at all will be effective, as it's usually the lightest part of your image and tends to compete with the rest of the picture.

As you look through the viewfinder, try to abstract what you see into simple shapes. A baby sitting on the floor may have the shape of a triangle; your neighbour's head may be perceived as an oval. The fewer the shapes that are present in a picture, the simpler the composition, and simple compositions are often the most dynamic. If there are too many shapes, they start to compete with one another.

Lines lead the eye across a picture, or to the point of interest. Think about what lines are present in your image as you look through the viewfinder, and decide whether they are creating the desired effect. Straight vertical and horizontal lines imply structure and stability, while curving lines appear more gentle. Not all lines in a picture are visible: in portraiture you'll often get implied lines that begin at the eyes, especially when the subject is in profile or looking into the distance.

Balance is very important in visual design. When you look at a photograph and it appears one-sided, or something appears too central, odds are that the image is not well balanced. As a photographer, you need to relieve that tension and make sure there is balance in your composition between shapes, tones and colours. When photographing people, this applies not only to images of a couple or a group, but also to those of a single person. In a photograph of a couple, the two figures will usually balance each other. In a single portrait, you can achieve balance between the model and an object, perhaps a musical instrument, a house in the distance or a clump of flowers. When you look at the photograph on page 43, your eye goes to the girls first, then to the lighthouse in the distance. There is balance between the figures and the lighthouse, but also between their colours.

Lens selection will help you control perspective (the illusion of depth) in portraiture. Unless you're shooting environmental portraits, avoid using ultra-wide-angle lenses (anything below 20mm). If you have to use a wide-angle lens, perhaps because of space restrictions, remember that distortion is greatest near the edges of the frame, so place your subject close to the middle. Long telephoto lenses (300mm and above) also distort perspective: your subject's features, especially the nose, may appear flat, because of the compression effect inherent with long lenses.

The rules of composition will add impact to your portraits, but do remember that rules are made to be broken, especially when you are trying to make a statement with your images. A tiny figure in the corner of your picture, close to the edge of the frame, will likely draw a lot of attention because of its positioning. Don't be afraid to be creative and experiment with unconventional compositions. Be bold rather than play it safe. Try different lenses and viewpoints. You'll be amazed by

how different perspectives will alter the background and affect the outcome of a portrait.

Freeman Patterson's books *Photography and the Art of Seeing* and *Photographing the World Around You* explore visual design in great detail. They're great books, worth reading over and over again.

Background

The background plays a very important part in a successful portrait. You want it to complement the image rather than compete with the sitter. Simple backgrounds are best suited to portraits. When photographing outdoors, look for plain walls or natural settings you can throw out of focus. Avoid busy backgrounds or very colourful ones, unless they tie in with the portrait. A fireman photographed in front of a red fire engine with shiny chrome makes sense. The truck is relevant to the portrait; otherwise, such a background would be distracting. When choosing a background, always look for elements of distraction and ask yourself, Is this too busy? Are there any bright areas that will detract from the subject, even if they are thrown out of focus? Will objects appear to be coming out of people's heads (trees, lampposts, toys, etc.)?

It's surprising how little details can ruin a beautiful portrait. A few years ago, I photographed my friend and neighbour Don with his one-year-old son. Jaden was sleeping on his father's chest, so I asked Don to pretend to sleep. I propped up a cotton sheet behind them as a neutral background. When I showed Don's wife, Michelle, the pictures, she looked horrified. The sheet I had so carefully placed ended up looking like the interior of a coffin—and both of my subjects had their eyes closed. When I saw what she saw, I was also horrified. Lesson well learned.

To an extent, you can control the effect of a background by your selection of depth of field. The more out of focus a background is, the more separation you'll appear to have between it and the people you're photographing.

Props and clothing

Props and clothing can also contribute information about the person you're photographing. A musical instrument, a sports jersey or a uniform tells us something about the person in the portrait. When I photograph artists, I try to include some of their work in the photograph. I may use one of their pieces as the background, as in the photo on page 46, or I may ask them to hold a piece they've worked on. For children, a good prop can be a favourite toy, a pet or perhaps a ball. The young boy on page 49 was fond of soccer, so I photographed him in the alleyway where he was playing with his ball. Clothing can tell you a lot about the personality of the person wearing it, or can indicate what she does for a living. As with backgrounds, keep in mind that props and clothing should complement the model rather than compete with her.

Posing

Posing is a very important part of portraiture. If you're photographing outdoors, or inside using window light, begin by positioning your subject according to the light source. Remember the rules of composition when posing your model. The creation of simple shapes within your frame and the effective use of lines will strengthen the final image.

For more on posing people for portraits, see page 54.

Cropping

Cropping can be done to improve your images at the printing stage if you are not happy with the composition of your photograph once you see the result. With the use of an enlarger, or a photo editing program on your computer, you can reduce the amount of surroundings or background by opting for a tight crop on your subject. I'm always careful when cutting out parts of the body, such as the tops of heads. Although it's acceptable to do so (it emphasizes the eyes), I do it sparingly. When shooting people as part of an assignment for a client, or when shooting a commissioned portrait, I leave it up to those individuals to crop or not. A long time ago, early in my career, I was hired to photograph a young child. In most of the shots, I did a lot of cropping. Upon viewing the results, the girl's parents could not understand why I had cut off the top of their daughter's head. A valuable lesson. The same applies to hands and limbs. It's acceptable to crop limbs, but not so close to the hands, knees and feet that it looks awkward.

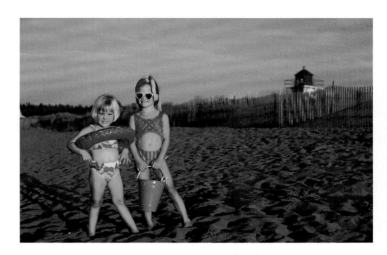

I arranged to photograph some children on a beach in Shediac, New Brunswick. The light was warm and beautiful, and the kids were great. I wanted to include the lighthouse in the image, and positioned it in my composition so that there was a sense of balance between it and the girls. Your eye goes first to the children, then to the lighthouse, then back to the girls.

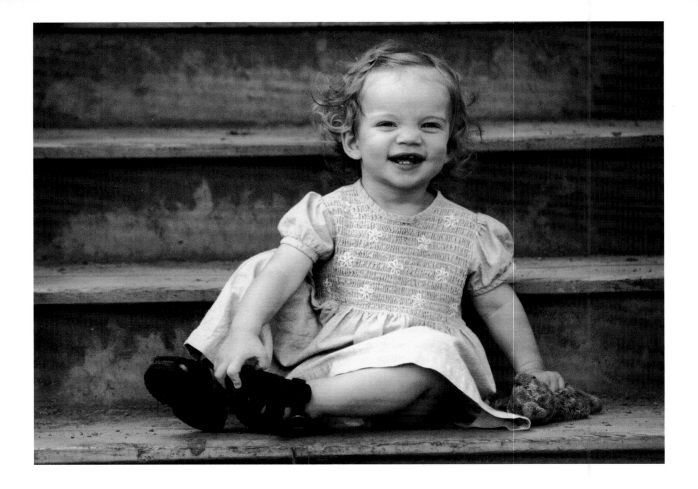

Riley was one and a half, and very timid. My friend Sandy, her grandmother, asked me to take a portrait of her, and I decided to do the shoot in a park. When we got there, I noticed that Riley seemed intimidated by me and all the people who were in the park that day. I found a quiet spot, removed from the distractions. In the shade was a set of weathered wooden stairs that would make an interesting background. Sandy sat Riley on the stairs while I steadied my camera on the tripod. Looking through the viewfinder and abstracting, I noticed instantly that Riley sat leaning to one side, causing her body to take on the shape of a triangle. I felt good about the simple composition.

When I was ready to photograph, Riley, on the verge of crying, wanted to get up. I took one of the props, a stuffed animal named Whisky, gave it to Sandy and, in a whisper, asked her to make the cat dance on my head. Riley watched, intrigued, and I took a few photographs. I then asked Sandy to make Whisky jump up and down on my head, and I started to yelp. Well, that did it! The child burst into laughter, and I clicked the shutter. The more I screamed, the more she laughed. The result was the shot above.

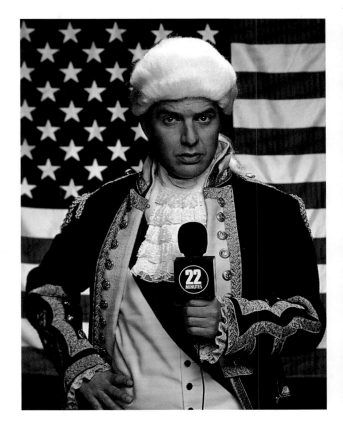

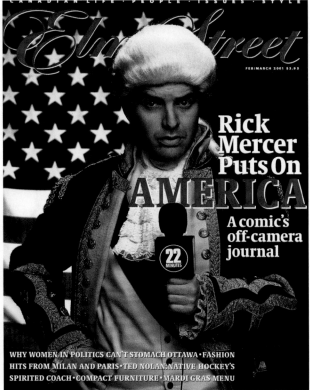

The art director of *Elm Street* magazine commissioned me to take a portrait of comedian Rick Mercer for its cover. I travelled to Halifax with my strobes and, as per the art director's request, my medium-format camera and colour reversal film. I had a window of two hours for the shoot, with ample time to set up beforehand. I transformed a radio newsroom into a studio space, setting up my lights and choosing a background.

The magazine wanted a portrait of Rick wrapped up in the American flag, an allusion to his popular segment, "Talking to Americans" on *This Hour Has 22 Minutes*. However, when I spoke briefly with Rick, he informed me he was not going to wear the flag and had decided to dress up as George Washington. Since I knew what the magazine wanted, I used the American flag I'd rented earlier as the background.

Although the shoot went very well, I wondered what *Elm Street*'s reaction to the photographs would be. They were less than happy upon receiving the images, but once I explained the situation, they realized that Rick's choice of wardrobe was out of my hands. In the end, they were truly pleased with this cover.

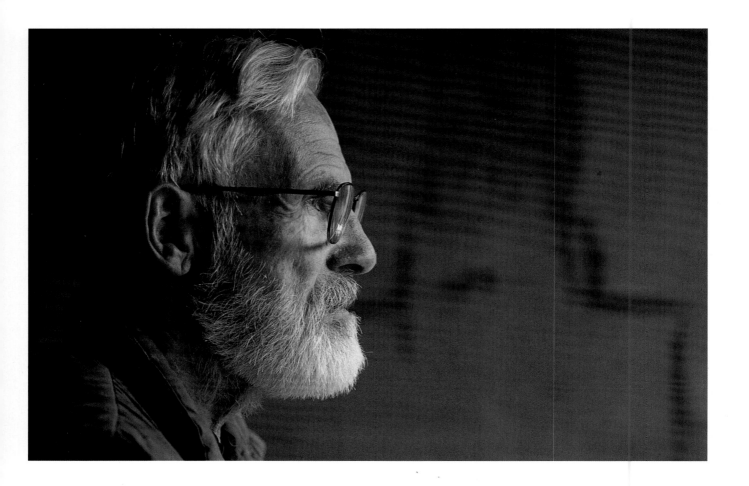

When I photographed John Hooper, I chose one of his early sketches for the background, selecting one that was simple and not too colourful or busy. I felt it was relevant to depicting John, the artist. Using only window light, I posed a profile and photographed using minimal depth of field.

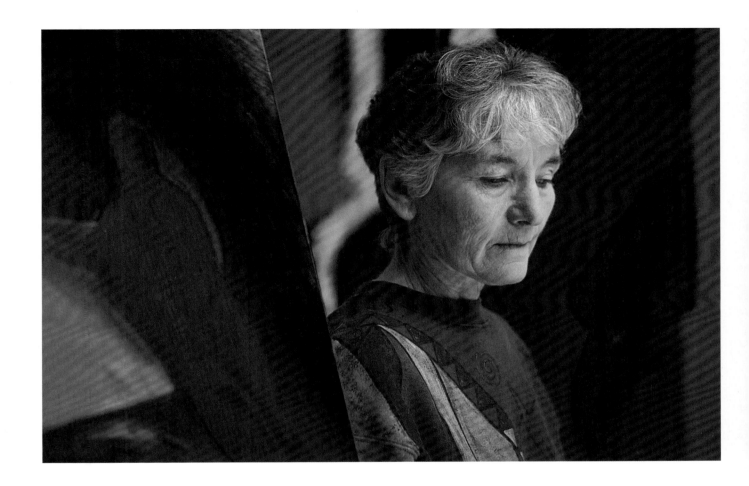

When I photographed Kathy Hooper (John's partner, also an artist), I decided to have the background play a larger role in the portrait. I used Kathy's colourful paintings in the foreground as well as in the background. What Kathy was wearing the day of the sitting was fortuitous. The painter's studio windows afforded wonderful soft, diffused light. I took many photographs, but this one, when Kathy looked down was the most expressive and serene.

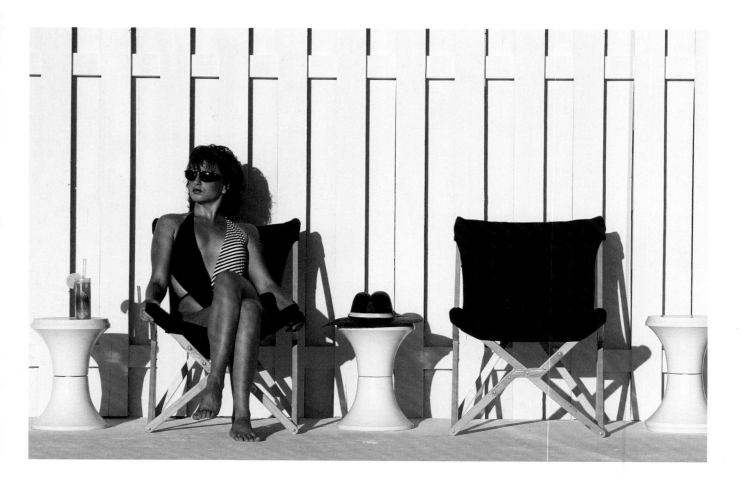

In this image, props play an important role and the background proved to be more work than taking the photograph. I had in mind a beauty shot of a woman in a bathing suit, in an attractive setting. First, I painted part of the fence behind my brother's house, putting two coats of white paint over the peeling brown wood. Then I realized that the cement needed to be white as well. Through a mail-order catalogue, I purchased a selection of swimsuits. Finally, I bought a couple of canvas chairs to complete the setup. My friend Pauline graciously posed for me. The light is natural and slightly to my left, creating shadows on the fence. My brother was less than impressed, by the way, that only a fraction of his fence got painted white.

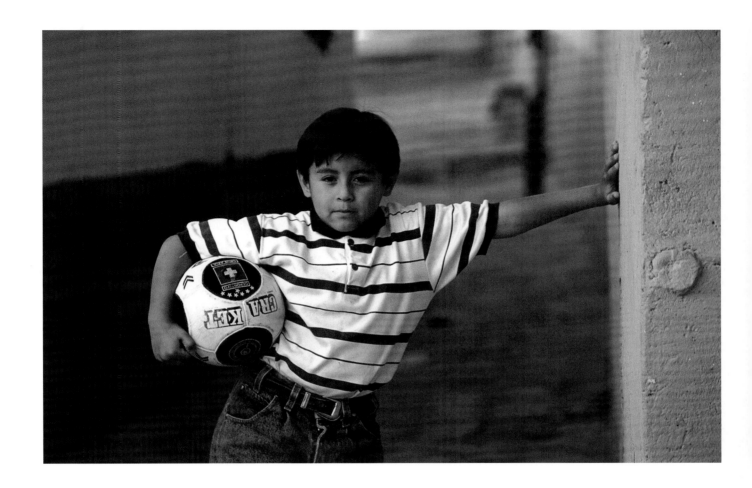

On a trip to Greece, I came across a few boys playing football (soccer) in an alleyway. I took photographs of them in action, then shot a portrait of the boy who appeared to be in control of the game. Just before pressing the shutter, I handed him the ball, which tells viewers what this kid likes to do with his free time.

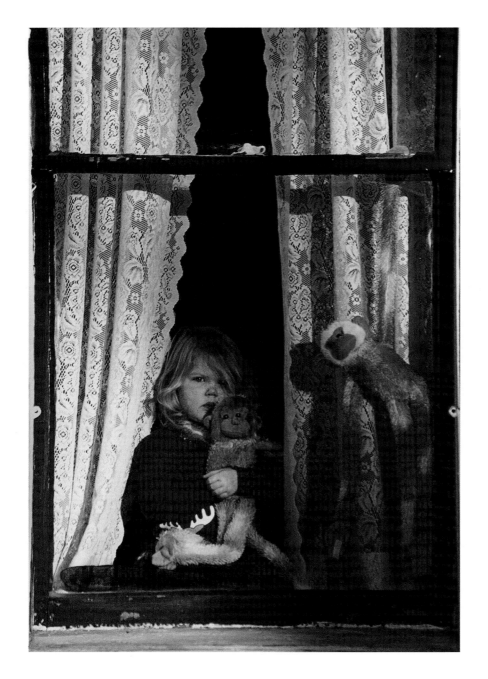

One day I went to a store to buy some candy, and they had on display cute neon-coloured monkeys that you can wrap around kids. At $4.99, they were quite the bargain, and I knew they'd come in handy as a prop when photographing children. The window in my neighbour's house gets beautiful light forty-five minutes before sunset. I arranged with Michelle to photograph a couple of the children in her daycare, using the colourful props. Shea wore a monkey around her neck, while another one hung from the window frame. The setting sun warmed the scene and added catchlights in the girl's eyes as well as those of the green monkey. Standing in the middle of the road, I used my 70mm–300mm zoom lens (set at about 150mm) and shot a roll of 100 ISO slide film. Because of the child's serene mood, I liked this image the most.

PHOTOGRAPHING PEOPLE AT HOME

Every photographer starts off feeling intimidated about taking pictures of people. One of the best ways to learn is to ask the people you know best—your family and friends—to pose for you. They will likely want to help and will be flattered that you asked to photograph them. Let them know you want to improve your photographic skills and, in return for letting you take photographs, you will give them some prints from the photo shoot. Telling them you hope to learn from the photo session takes some pressure off should the results not be what you were hoping for.

Include your subjects in the project by asking what kind of portraits they'd prefer and what clothes they'd like to wear, whether formal or casual. Find out if they have a favourite place, or what setting they'd like to be photographed in. Involving them in these decisions will help them feel more comfortable when they get in front of your camera.

If your first photo shoot does not work out as well as you anticipated, try again and don't get discouraged. You will still have learned something about photography and about how to work with people.

A great way to improve your skills is to take on a small project. Photograph an agreeable friend or family member over the span of a month or a whole season, trying posed images, environmental portraits and action shots. Or document "a day in the life" of a child, perhaps your own, a niece or a nephew. Such projects will be treasured by everyone involved for decades.

As you become comfortable photographing people, they will start to ask you to photograph them. Taking on these assignments will challenge you, and you will learn from the photo sessions and from working under pressure. But don't commit to anything if you feel you are not ready. A long time ago, I remember being asked to photograph a wedding. My pictures at the time were adequate, but they were of nature scenes such as flowers, lakes and meadows. I had the good sense to refuse the offer because I was not ready to photograph such an event.

Because of my portraiture, I've met interesting people, made a lot of friends and glimpsed different cultures. My camera has opened many doors for me. If you can put aside your shyness and open those doors, you'll end up with photographs you'll cherish forever.

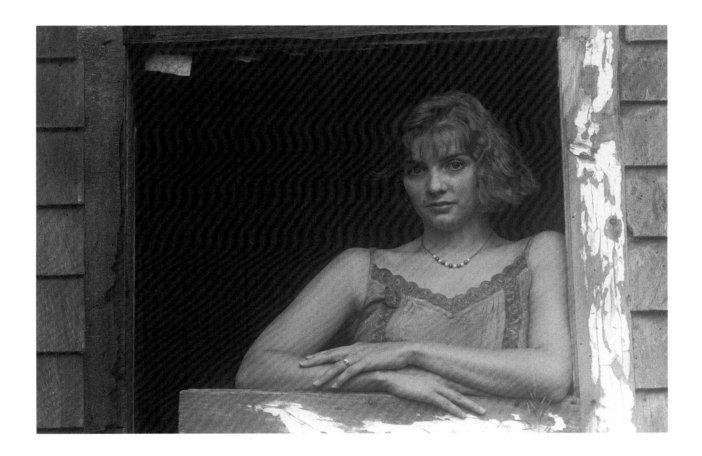

Rose is a wonderful friend, and she's like a sister to me. When I began photographing people, she was always willing to pose for me. For this image, we drove to an abandoned house near Edmundston, New Brunswick, where we both lived at the time. What I liked about this place was its old, weathered look, and I thought it would make a nice background for a portrait. We endured the black flies just long enough to expose a roll of black-and-white film with an ISO of 400, which I later processed in Rodinal chemistry (an Agfa developer that renders a beautiful grain). We were both very pleased with the result.

The single portrait

As much as possible, I try to shoot portraits outdoors. I usually schedule the shoot when the light is most flattering, a couple of hours before sunset. This gives me time to scout the area for an interesting background and to chat with the person I'm going to photograph while I set up, perhaps breaking the ice if we're not already close.

When I'm ready to begin, I figure out how my subject will look best and demonstrate the pose I want him to take. Then I make sure he is comfortable, as any discomfort will come through in the photograph. At the same time, certain poses are more flattering than others; for example, a straight back always looks better than a slouch. For a self-confident and or relaxed look I may ask the model to cross his arms.

I rarely photograph someone straight on unless I'm looking for an authoritative or severe look. Instead, I position my model at a slight angle to the camera so that her shoulders do not form a straight line. This gives a more relaxed feeling to the shot and, as a bonus, her body appears thinner (you won't find many people who will argue with that!).

In a portrait, the eyes are very powerful. As the saying goes, eyes are the windows to the soul. When the subject makes eye contact with the camera, the viewer feels very connected to him. When he looks away, he seems detached and mysterious. When his eyes are closed, or he is looking down, he can appear pensive or lost in a dream. Whenever you have to sacrifice depth of field, make sure the eyes are in focus. If your subject is at an angle, and you can't get both eyes focused, the eye closest to you takes precedence. If your model wears glasses, avoid reflections by asking him to tip his head downwards, then shoot from a slightly higher angle. And remember that catchlights in the eyes make a portrait come to life.

When you're posing your model, ask her to tilt her head slightly to one side: it looks more relaxed and adds dynamic to the portrait. It also slants the eyes a bit and creates an interesting line in your composition. If your model is at an angle, but not quite a profile, make

sure her nose is contained inside the contour of her cheekbone.

People tend to frown when they're being photographed, but when they're made aware of this, it's usually easy to get them to relax their forehead muscles. A high camera angle may be helpful in concealing a double chin, and shooting in profile can conceal a lazy eye or uneven eyes.

Hands can be very expressive and can play a large role in a successful portrait. Whenever possible, show the hands but, unless you want a hands portrait, make sure they don't receive more light than the face. If your model's hands are close to his face, position them to show the side or back. Resting the chin or cheek on the hand is a popular pose; just make sure the hand is touching the face lightly so not to push and distort the skin. When your model is standing, his hands can be a problem, more so if he is timid and nervous. I sometimes ask a model to put his hands in his pant pockets, which gives a casual look. If there is something to lean against (a wall, a tree, a lamppost), the model can put his hands behind his back. Or he can hold a prop (a musical instrument, a tool, a knapsack, sunglasses).

Shooting at a low angle will produce a sense of dominance, as you're looking up at the person you're photographing. This could be an ideal way to photograph a person with authority. Shooting from a high angle produces the opposite impression, which can be very effective when photographing children to illustrate their small size and vulnerability.

With a bit of direction, it's fairly easy to get a variety of expressions from your model and to change the dynamic of the pose. Ask her to tilt her head slightly to either side, to lower her chin, to turn her head for a profile, to cross her arms or put one hand in her pants pocket. These small changes can make a big difference. Shoot until you feel you've got the shot.

As you photograph, keep chatting to your model; long silent pauses may intimidate him. And be ready to capture that special moment. It could be a spontaneous expression, such as a burst of laughter or a frown, or an action you did not anticipate, such as a child jumping in a puddle with a devilish look on his face.

Couples

Couples often request formal portraits for special occasions, such as weddings or anniversaries. The typical pose captures the subjects holding one another and looking into each other's eyes. When taking a formal portrait of a couple, having one person slightly higher than the other is more visually pleasing. As when you're photographing one person, you can have your couple at an angle to the camera rather than shooting them straight on. It is also effective to have one person sitting and the other standing slightly behind, perhaps resting a hand on his or her partner's shoulder. This type of posing works best if you are doing a full-length portrait, because the heads will appear too far apart in a close-up shot.

Once you feel comfortable with the formal portrait you've taken, you may want to encourage your couple to let loose and have fun. Take lively shots of them interacting with each other, perhaps riding together on one bicycle or walking in the rain. Once, on a shoot for *Canadian Living* magazine, I photographed a couple who owned and worked in a restaurant. First, I did the obligatory posed portrait. Once I felt comfortable with the shots I had taken for the magazine, I took a few extra

photographs to satisfy myself. Looking for a more animated portrait in which the couple appeared to be having fun, I had them dance the tango in their restaurant. We put some music on, and they played the part beautifully. Which pictures do you think made the magazine?

Family Portraits and Large Groups

A common way to take a family portrait is to have everyone stand or sit together, arranged in a formal manner. Check that the light is even on all the family members, then make sure people look relaxed and have nice expressions. Then cross your fingers and take the photograph.

Be aware that the larger the group, the more difficult it will be to position everyone appropriately. It's particularly effective if people's heads are spread out evenly throughout your composition. Rather than have your group stand or sit in a line, arrange them so that some are sitting down (on chairs or a bench), while some are standing behind, at an angle to the camera. In a large group, you might even want to have some of the people kneel down in front.

If you're looking for a more visually interesting photograph, position yourself higher than the group and shoot down. It's not uncommon for professional photo-graphers to use a step ladder when photographing large groups. The perspective is more interesting, and it's easier to see everyone's faces when they're looking up at you.

Family portraits don't have to be static or contrived. With a bit of imagination, you can come up with ways to photograph a family having fun or posing in an unusual setting. Think of words like "off the wall," "joyous" or "energized" and use the family to illustrate them. Photograph a young couple building a snowman with their children, making a sand castle on the beach or raking leaves. Set up next to a weathered fence in the country or on top of a small hill, shooting up from a low angle, with a blue sky for your background.

With large groups, remember that your chances of getting the right look from everyone are very slim. Odds are you'll have plenty of awkward expressions and, in many shots, one or more people will have their eyes closed. Take a few extra pictures if you're shooting film. With digital, you can shoot to your heart's content and delete the ones you're not happy with. If you've taken many photographs of your group and can't find a single shot in which everyone looks good, don't despair: you can work a little magic with a photo editing program, swapping people from one group photo to another.

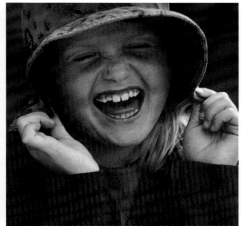

I photographed Sarah on a beautiful beach in the Queen Charlotte Islands. My good friend Karen was helping me with the photo shoot, and she was holding my collapsible reflector in front of the young girl. After I took a few posed portraits of Sarah, Karen and I started acting up, and we encouraged Sarah to be goofy as well. What followed was a series of outbursts of laughter and spontaneous expressions. This exercise shows what is possible when people are at ease in front of a camera. Tom and Jenn, Sarah's parents, were ecstatic when they received the pictures. They felt I'd captured the spirit of their daughter on film.

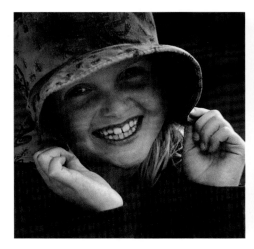
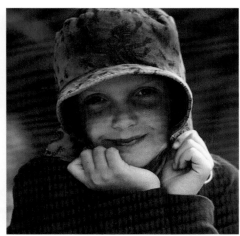

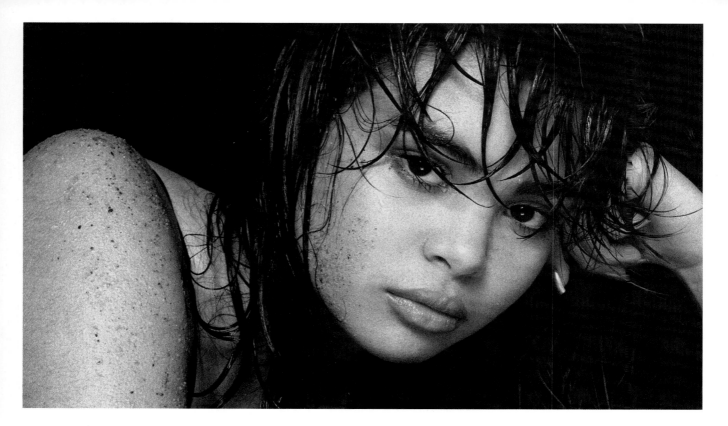

Ever since I can remember, my friends have been very support- ive of my photography, wanting to help out whenever possible. I could always rely on them when I needed to practise setting up and balancing my studio lights or when I wanted to create a new shot for my stock agency or my portfolio.

I noticed Christine in a local fashion show when she was just thirteen. Shortly thereafter, we started to work together and she became a good friend. Although she was initially a bit timid, she was a natural in front of the camera. We planned photo shoots on weekends whenever possible. With Christine's help, I learned a lot about working with natural light and with strobes, and about directing people in front of the camera. After the film was processed, Christine and I would study the contact sheets to see what worked well and what needed

improvement. I would always print a couple of 8 × 10s for her portfolio. These photo sessions benefited both of us. Chris- tine now lives in Montreal, and I miss her dearly. We share wonderful memories.

This image of Christine was photographed in my backyard. We decided to do a beach look—without the beach. My friend Kerry wet Christine's hair and styled it, then Myriam, the makeup artist, did her part, knowing that the shoot was in black and white. I used a piece of black fabric a the back- ground, and we wet Christine's upper body, smearing a bit of sand on her cheek, shoulder and arm. The light was natural (it was a bright cloudy day) and I used a reflector to fill in the shadows and add a catchlight to her eyes.

Julie is another good friend and
model whom I met through my
photography. This image was
taken at a cathedral in Edmund-
ston, New Brunswick. We were
after a classic romantic look, and
this church provided the right set-
ting. I photographed Julie on a
bright cloudy day in front of a
large granite urn at the entrance
to the cathedral. My choice of
film—a grainy film with hairspray
coating an 81A warming filter—
added to the antique look of the
photograph.

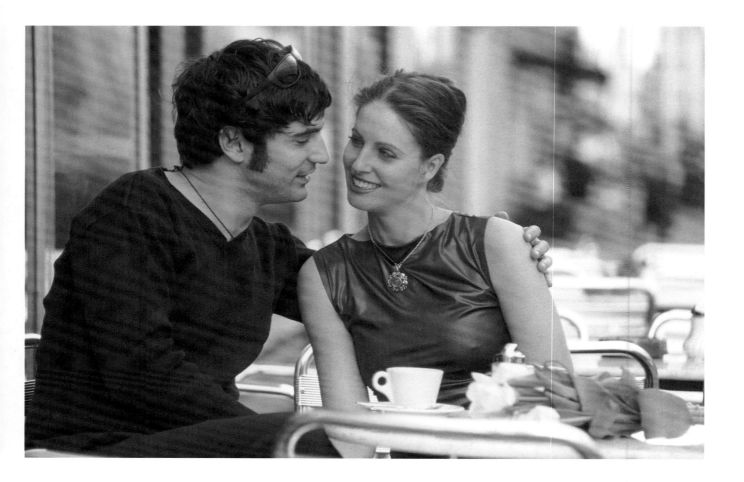

When I visited my friend Julie in Berlin a few years ago, we decided to do a quick photo shoot for old time's sake. I wanted to photograph Julie with her partner, André, in an outdoor café. We found a small restaurant with outside tables that wasn't too crowded. I noted where the light was coming from, chose a table for them and ordered two coffees. Using my 80mm–200mm f2.8 zoom lens and Agfa Scala black-and-white slide film, I took photographs of the couple interacting. I chose to shoot with my lens fairly wide open (f4 or f5.6) so I could blur the background. After this shot, we moved on to a park, where I photographed them among statues, fountains and large granite urns. We all enjoyed our afternoon tremendously. When I got home, I sent Julie a selection of images for her portfolio, and I placed a few images with my stock agencies.

This portrait of my partner, Parker, and me was taken in the doorway of a beautiful old kasbah that now serves as a hotel in Skoura, Morocco. With my camera on the tripod, I composed the image to include the interesting details surrounding the doorway. I then focused on Parker and used the self-timer so I could be included in the photograph. Notice that, as Parker s sitting and I am standing, there is an implied oblique line between our two heads. The shape of the frame in the image is repeated in the shape of the doorway, and the two figures offset the symmetry.

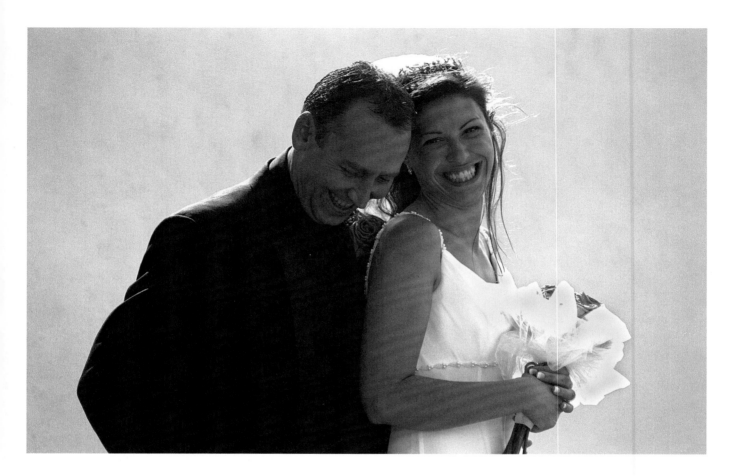

When my friend Daniel got married, I brought my camera with a couple of rolls of 400 ISO black-and-white film to the wedding. Although they had hired a photographer, Rebecca and Dan were very pleased when I offered to take their portrait.

After the ceremony, as soon as the bride and groom were done making the rounds of their guests, I whisked them away for the shoot. We returned to the small church, conveniently located next to their home. The image above is my favourite of the photographs I took that day. For me, this is the Daniel I know so well, and his beautiful bride, Rebecca. I love their spontaneous expressions.

How many times have I photographed my good friends Tom and Diane and their children? Too many to count! Here, at Parlee Beach in New Brunswick, I photographed Tom and Diane in the beautiful warm light of sunrise. I asked them to ignore me and whisper to each other. The mood of the portrait is intimate and reserved because we don't see their faces. Although I took many pictures in which the couple was more prominent, I prefer the discreet feeling of this composition.

This photograph was taken at Miscou Island for Tourism New Brunswick. The shoot was planned so we could take advantage of the soft and warm light of early evening. I also made sure there would be plenty of copy space for the tourism ads.

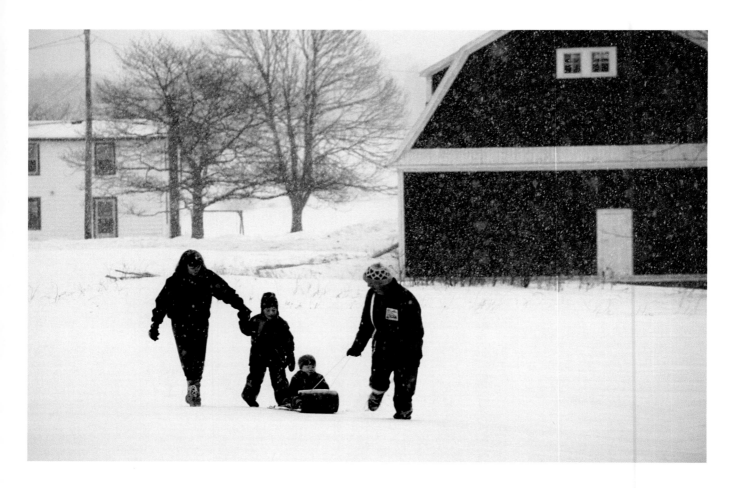

While shooting images for *Winter*, my first collaboration with the late Pierre Berton, I was staying with friends in Nova Scotia. On the morning of my departure, it began to snow quite heavily. Large snowflakes drifted down slowly from the sky. It was magical. I seized the opportunity and asked Debby and Jim if they'd like a portrait of their family enjoying the snow. Moments later, they were rushing to get Amanda and Christopher dressed, and I was getting my gear ready. Because this shoot was unplanned, I had no idea where to take the picture. Jim knew of a location nearby with a rustic house and a red barn in a large, open field. This sounded perfect to me. I instructed my friends to walk towards me while interacting with each other rather than looking at the camera. This is the picture I was hoping for: a family enjoying a snowy day.

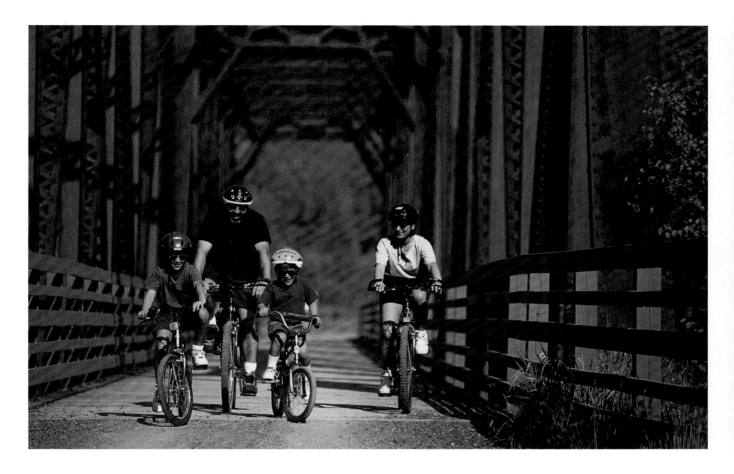

This family portrait was photographed while I was on assignment for the city of Edmundston. The city provided me with a shoot list and I was to include people in the photographs as much as possible. I asked Tom and Diane if they'd pose for me with their children. They live near a biking trail and are all cyclist enthusiasts.

From what I remembered of this old train bridge, now part of the trail, it seemed like a good place to do the shoot. My friends and their children met me at the bridge. After a quick briefing, they rode their bikes close together, and I photographed them as they came towards me. With the sun strong, they wore sunglasses so they wouldn't squint. We did quite a few takes because I needed a shot in which all of the family members were visible, in focus and had the right expression. Many of the images from the shoot were successful, and since then, we've seen them used in tourist brochures, magazine articles and even to grace a billboard that advertises travelling in New Brunswick. The shots have been popular because they say summer, fun, family outing, sport and unity.

Pictures of family and friends document life, love and relationships: the unity of a couple sharing their life together, the bond between a mother and her infant, the closeness of siblings, the trust and affection of good friends. I'm always amazed at how nostalgic I feel when I go through the wooden box that contains old photos from my family's past. The black-and-white prints of my father next to an old truck, with my two brothers sitting on the hood, or of my older sister wearing a poodle skirt, take me back in time, sometimes making me laugh, other times bringing tears. I'm so grateful that someone took these photos. Now I'm the one taking photographs for others to cherish.

When you first start photographing relatives and friends, choose someone you know well and are comfortable with: a parent, spouse, sibling or close friend. Children are the least intimidating models, but adults are easier to direct and have more patience and longer attention spans. Start by working with just one person and get the hang of that before you move on to photographing pairs and groups.

Instead of creating formal portraits, try photographing your subject doing something she enjoys. She will be more relaxed and less conscious of the camera. Does your mother like gardening? If so, take pictures of her planting bulbs, pruning shrubs, watering flower beds, or just sitting in a corner of the garden, relaxing with a cup of coffee. Your father might like a photo of himself on the putting green or driving a golf cart. By capturing someone in a favourite environment, you tell a story about them and add a personal touch to the portrait.

When you photograph someone in action, he is usually less self-conscious than he would be posing in front of a camera. On one particular assignment, I had to take a portrait of an artist to be included in a catalogue of her work. The fine weaver felt extremely uneasy standing in front of a camera "just doing nothing," as she commented. Upon her insistence, I photographed her while she was working on one of her pieces. The environmental portrait worked well, and she was pleased with the outcome.

One of my brothers, Pierre, loves fishing. One summer, I arranged a photo shoot with him and his younger son. On a sunny evening, we drove up to a nearby lake with a canoe and fishing rods. The water was calm, the sky was bright and clear, and the light was warm and soft. Pierre and his son Yannick got into the canoe and paddled a short distance. With the sun slowly falling behind them, father and son were backlit but not quite silhouetted. The still water began to reflect the sky's glowing orange hue as the sun neared the horizon. By the time the sun disappeared, Yannick had caught a trout and was holding it up to show his father. The silhouette of my brother and his son hangs in the living room of their house. Every time I see it, I'm reminded of our special evening that summer.

As you grow more comfortable photographing people, start taking your camera to family events: birthday parties, holiday dinners, barbecues. By now, word of your hobby will have spread, and your relatives and friends will be happy that someone is documenting the occasion. These are great opportunities for relaxed, natural photos, as everyone is having a good time. At this point, you can start to incorporate people you don't know as well into your photographs, and you'll be well on your way to getting up the nerve to photograph strangers (see "Photographing People Around the World").

Vicky, my niece, has found herself in front of my camera many times. This image with three kittens was photographed in an empty warehouse on the outskirts of Edmundston. A large opening let in enough light for me to photograph on a tripod using 100 ISO slide film. I used a reflector to fill in the shadows, and a soft-focus filter gives the photograph a nostalgic feel. Vicky was very patient with her uncle. After the photo session, I was surprised to find her arms full of scratches—she never once complained! Today, Vicky has three kids of her own, and I'm back behind the camera photographing them.

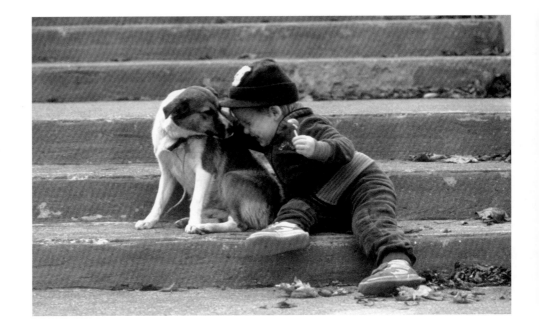

Although I like these images from a photographic point of view, I love them on a personal and emotional level. This is my nephew Ben. I've watched him grow up in front of my camera. At twenty-three, he's now taller and bigger than me, but he's still little Ben. These photos were taken when I was just beginning to photograph people and Ben was three. I took my nephew and his dog, Spiroune, to the cathedral in Edmundston. I liked all the stairs that lead up to the church and wanted them for my background. I set up my camera on the tripod, gave Ben a lollipop and waited for the magic to happen—and so it did. Whenever I see these two pictures, I wonder where the time has gone.

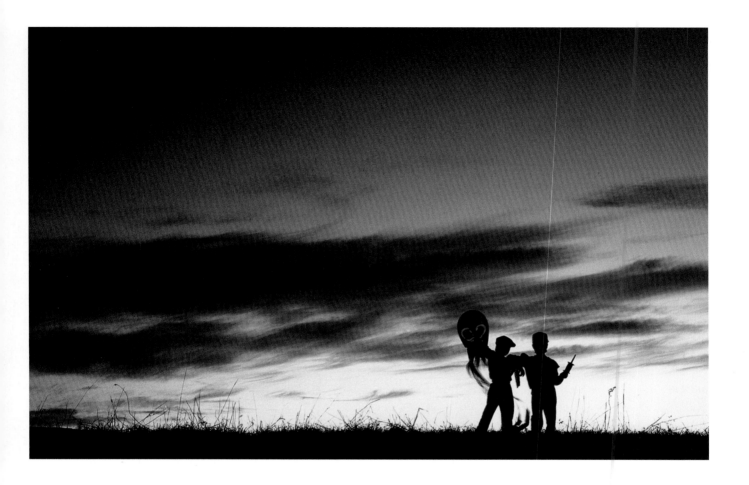

Ben and Vicky's older brother, James, has also found himself in front of my camera on many occasions. In this photograph, he's posing with his friend and neighbour Richard. I had just photographed them flying a kite in the evening light and

thought it was worth waiting for sunset. The sky darkened, and the clouds picked up nice colours. I took this silhouette of the boys by exposing for the sky. This was by far the better image made that day.

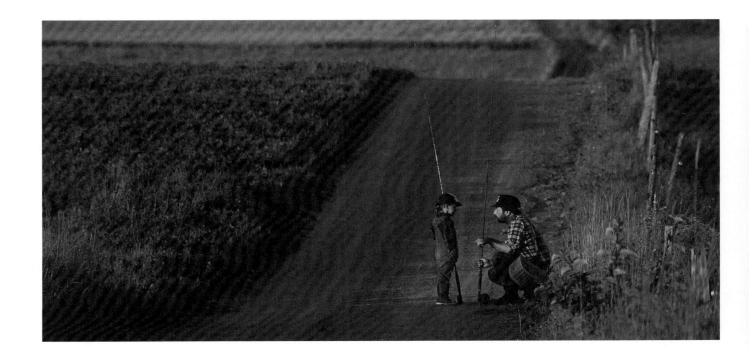

More than ever, we see images of fathers involved with their children, and I wanted a stock shot of a father and son doing an activity together. I asked my brother if he'd pose for me with his older son, Joey. I had an image in mind of a father and son going fishing, perhaps walking hand in hand on a small dirt road. Pierre agreed, and we planned the shoot for the next day. With the weather cooperating, we drove to a spot I'd come across earlier that summer, a beautiful winding road in a country setting. I knew how the light would fall there in the evening (there is nothing worse than planning a shoot in a beautiful location only to find out the light's direction is wrong when you arrive).

When we got to the location, I discussed the planned image with my brother. I wanted them to interact with each other, not looking in the camera's direction, so Pierre was to occupy Joey, telling him stories, while I took my pictures. With the soft, warm light casting elongated shadows on the winding road, I made my photographs using a long lens (80mm–200mm f2.8) to distance myself from my subjects and prevent me from intruding on their moment together. The lens also enabled me to blur the background in the distance, shooting with the aperture fairly wide open and zoomed all the way to 200mm.

Parker's mother, Judith, loves life. I wanted to photograph her in various settings, and I chose to do the photo shoot at Freeman Patterson's house. We drove up together late one summer afternoon so we could take advantage of the wonderful evening light. I shot Judith, an avid gardener, in the garden, pruning the roses and weeding. We also did some formal por- traits with the flowers and Freeman's beautiful weathered barn in the background. Finally, we moved to the front deck of the house, and I photographed Judith looking out into the dis- tance, making sure the shaded part of the house was behind her to ensure background separation.

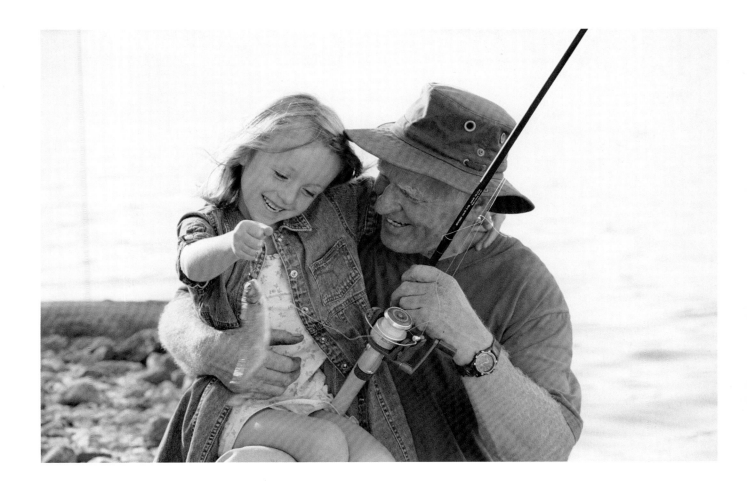

My friend Terry is a special man and a wonderful grandfather. I asked him if I could take a picture of him and Nakia, his six-year-old granddaughter. Terry agreed, and we decided to do the shoot at his place, the Adair's Lodge and Cabins near Kingston, New Brunswick. I envisioned a shot of them fishing, and we went to his wharf by Kingston Creek so we could have water in the background. For the shoot, I used chromogenic black-and-white film with an ISO of 400. The late afternoon light was in the back and slightly to the side of Terry and Nakia, highlighting their hair and sides. A reflector bounced plenty of light onto them. While I was shooting the portrait, I could not tell who was the child and who was the adult in front of the camera. I'm sure that is why there is such a special bond between them.

Photographing children can be exciting and rewarding. Patience and imagination will help you capture precious moments. Rather than posing them, try to capture their spirit and exuberance. Be prepared for the unexpected, and embrace it. Get down to their level, physically and mentally. If you act silly with them, they'll play along. If the resulting photographs bring a smile to your face, chances are you've succeeded in capturing kids being kids.

In the beginning, photograph just one child rather than trying to handle three or four. Keep your shoot as simple as possible. You might want to set your camera to auto-exposure or to shutter priority, choosing a shutter speed of $\frac{1}{250}$th of a second to ensure sharp photographs. When you don't have to worry about exposure, you can concentrate on composition and getting your shots, especially the candid ones. As you gain experience, you'll get better and better at it, and your work will mean a lot to the parents whose children you've chosen to photograph. A few of my friends have a small permanent gallery of my work hanging in their houses.

Looking at their walls, you can see their children growing up before your eyes.

Remember that a child's attention span is very short: you must be well prepared. You can maximize your shooting time by choosing a familiar location and knowing how the light will fall at the time of day you want to photograph. Have your camera loaded with film and fresh batteries. It's also good to have an idea of the type of images you want to take, whether a posed portrait or candid action shots. But be ready for spontaneous moments, when children do what's fun and what feels natural to them. My favourite images of children are those I've taken when they're doing their own thing.

A bright cloudy day provides even light and is an ideal time to photograph children. You won't have to worry about harsh shadows, and there'll be no strong light to cause little ones to squint. A reflector (white, silver or gold) is often useful to add light to the face, and may produce a sparkle in the eyes. If you are using colour film, an 81A filter (light amber in hue) will warm your images, ridding them of the blue cast that

occurs on cloudy days and when you photograph in the shade. On a sunny day, early morning and evening (the hour after sunrise or the hour before sunset) are good times to photograph children, as the light is warm and soft, rendering pleasant skin tones. Don't forgo photographing on rainy days, or when it snows. Remember when you used to jump in rain puddles? In the winter, kids love playing in the snow, building a snowman or making snow angels.

A tripod is a good idea, but don't be constrained by it. Children move around a lot, and it may be easier to use a fast film and hand-hold your camera. A short zoom lens with a range of 28mm to 80mm is less prone to camera shake than longer-ranged zoom lenses.

Recently, I've been photographing children using colour and black-and-white print film as well as slides. Negatives are more forgiving of inaccurate exposure than slides, and I say "thank you" to parents by giving them a set of prints.

I always take food along on a photo shoot. If things aren't going well, I have a bag of goodies to rely on. A large piece of watermelon, although messy, can be a beautiful and colourful prop in a photograph. I also bring large, bright lollipops. When possible, I'll try to get an ice cream cone. It may be a cliché, but it's a good way to get fun images and keep everyone happy.

Young children and toddlers may be comforted by the presence of a favourite toy or pet. Stuffed animals can be very cute and can make a child feel more secure in your presence (cut off the labels so they won't appear in the photographs). Pets such as puppies and kittens can bring a beautiful expression to a child's face. Avoid hyper animals, as they may scratch the child or run away. Years ago, on a shoot with my niece, I borrowed two of my neighbour's bunnies. As I photographed Vicky with one rabbit, the other was left unattended and disappeared into the woods. I ended up with a lot of explaining and apologizing to do.

I find that if only one of the parents is present at the photo shoot, a child is more likely to pay attention to me. I ask the parent to stand behind me while I'm photographing to draw the child's gaze so she appears to be looking into the camera. While I'm getting ready (loading film, setting up a reflector, arranging props), I encourage the parent to distract the child. When I'm ready to start, I don't waste any time—children get bored quickly!

Babies

When photographing babies, I like to capture typical "baby situations": infants asleep in a crib, eating in a high chair, being rocked by a parent or grandparent. Photographing babies can be very challenging. You can't direct them or tell them what to do. Depending on their age, they can't sit up straight, stand well or walk. The photographer has to consider these things and turn them into an advantage. When I'm asked to photograph someone's baby, I ask a lot of questions to prepare for the shoot: How old is she? Does she walk yet? Sit up straight? Stand up in a crib? What's her room like (colour of the walls, size and number of windows)? What time of day is she most joyous? The more I know about the child's personality and routines, the better my chances of photographing successfully.

Because flash and strobes can startle an infant, even when he is sleeping, I prefer to photograph babies using available light, such as the light coming through a large window. Fast films (400 to 800 ISO) are useful in this

situation, and their graininess is sometimes helpful in concealing blemishes on a baby's face. (Blemishes are also less noticeable on black-and-white film than on colour film, but it's fairly easy to do your own retouching with a photo editing program).

Rather than propping up a baby who's not strong enough to sit, photograph her lying on her side or back. This will seem much more natural. Dress her in soft, pale colours, rather than in bright clothes that will compete visually with her. A baby wearing a diaper makes a beautiful photograph, as we get to see her delicate features. If she is awake and alert, watch out for sudden expressions, bursts of laughter and even tears. When she goes to sleep, don't put the camera away—this could make a very tender portrait.

Don't hesitate to include the child's parents in the photographs. What could be more peaceful than a baby held in his father's arms or being nursed by his mother as they rock gently? And don't overlook the small details, such as a baby's tiny hands or feet. A baby's little hand wrapped around his father's rugged fingers is a beautiful image.

Toddlers

When you set out to photograph toddlers, be prepared for the unexpected. Whether they are at the crawling stage or have just discovered walking and are all over the place, proud of their new achievements, they are not just going to sit still. A new toy, bright in colour, or a sound-making device such as a radio or portable CD player may intrigue them for long enough to allow a few shots. Don't introduce these items until you are ready to photograph.

I have often had success photographing toddlers in a plastic tub, with some water and lots of bubbles. With the child splashing away or playing with rubber ducks, the photographer has ample opportunity to take beautiful pictures. You might ask the parent to put bubbles on the child's head and cheeks. Imagine the possibilities. After the bath, have the parent dry the child and bundle her up in a thick towel (preferably plain and pale in colour). With just her face sticking out, this could make a cute picture.

Recently, while photographing my neighbours' daughter, I'd run out of ideas until I walked in front of the linen closet and spotted a couple of rolls of toilet paper. We set up in the bathroom and covered Maia in toilet tissue. She was all smiles, and the pictures turned out well. When I left their home, I noticed the beautiful tiles in their kitchen! Hmmm . . . next time, pots and pans on the floor—and perhaps a bag of flour?

I strongly recommend using a fast film combined with a zoom lens when shooting toddlers. For more intimate portraits, get down low and shoot at the child's eye level. Be alert, have fun and keep on shooting.

Kids Being Kids

Kids are full of life, active and spontaneous. When setting out to photograph them, be ready to capture instantaneous gestures, diverse emotions and changing expressions. You may have something in mind, but you'll soon realize who's in charge. If you're well prepared, you may be able to capture a slice of life as you photograph kids being kids.

Choose a familiar location, where the child will feel comfortable. Avoid crowded areas, as too much commotion will become a distraction. A playground is always a favourite with kids, and it's a place where you can get action shots, lively expressions and a lot of

colour. You may choose to follow the child as he's playing, having fun on slides and swings, running and jumping, laughing and screaming. It's playtime, so join in the fun!

A park also offers many opportunities. You might suggest that the child feed pigeons, or ducks if there is a pond. Or pose her on a weathered bench, eating a large colourful lollipop, an ice cream cone or strawberries. Parks usually have plenty of shaded areas, so if the sun is too strong you can move into the shade. With the help of a reflector or fill flash, you'll still have enough light to photograph your subject. If there is a lot of open space, try a few panning shots. (Panning is the action of following a moving subject with your camera, using a slow shutter speed of $1/15$th of a second or less and pressing the shutter as the camera is still moving—this will keep the subject fairly sharp and create motion with the still background. The slower the shutter speed, the more motion you'll obtain.)

The beach is another good place to photograph children. Kids love to play in water and sand. The right props—cute sunglasses, bright towels, a beach umbrella—can add to the final images. The best times to go are early morning and evening, when the sun is low in the sky and the light is warm. Try going on cloudy or foggy days too; the mood of your photographs will be very different under these conditions.

Photographing indoors, although more constraining and sometimes difficult to light properly, can also produce beautiful images. Try to capture everyday activities: children reading in bed or looking out a window, playing cards or eating pizza, ice cream or cereal. I've photographed kids dressing up in adult clothes and little girls trying to put lipstick on. I've even (after clearing it with their parents) had kids jump on their beds and have pillow fights.

When Jaden came home from the hospital, he was three months old. But because he was born premature, he was the size of a newborn infant. His parents, Don and Michelle, my next-door neighbours, asked me to photograph him. I went over to their house with my camera equipment, a tripod and a reflector. Because young babies often have blemishes, I felt black-and-white film was a better choice than colour. I also knew Michelle liked black-and-white portraits. And because I was photographing inside, I opted for the speed of 400 ISO film.

I have to confess I was not ready for this shoot and had no idea what I was going to do when I arrived. Seeing Jaden, I was surprised at how little he was. I can't imagine how small he must have been three months before. We went upstairs, to one of the bedrooms, near the window. I wanted to take a few shots of the baby's face as he looked at me or his mother. But before I could do anything, he fell asleep. I decided to take advantage of the situation and shoot some portraits of a father and his son. Asking Don to hold the baby high in his arms, I positioned them so that the window light was most effective. I then rushed to my camera, put on my fastest lens (an 80mm–200mm f2.8 zoom lens) and secured the camera to the tripod. I quickly composed and started to document this special moment. I took pictures of Don in profile, then asked him to look straight ahead so I could focus on Jaden, asleep on his father's shoulder. All of a sudden, Jaden smiled. Michelle and I held our breath, and I clicked the shutter. "Sweet Dreams" was a complete surprise and a very tender moment.

To show how small the infant was, I asked Don to hold Jacen in his hands for one last set of photographs. Still using the window light, I took a few shots. The room's wall, painted burgundy, provided a nice dark background. When I got the prints back, I noticed that Don's wedding band was showing, and I thought, "What a nice coincidence."

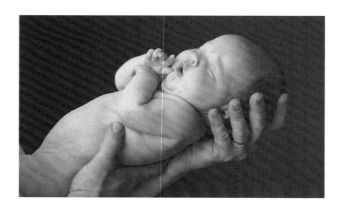

François at six months was a fun baby to photograph: he smiled all the time. I arrived at my friend Diane's house with one strobe light, a reflector and my camera equipment. I added a soft-focus filter to my lens, as I really like its effect when I photograph babies. François, Diane's son, was very active, so we decided to have him sit in a small plastic container. Thus confined, he would be easier to photograph. I set up my light, diffused by an umbrella, and got my camera and film ready. Diane dressed François in cute pyjamas, and we put a baseball cap backwards on his head. I asked Diane and her husband, Tom, to stand behind me so that François would appear to look into the camera as he sought out his parents. The boy cooperated nicely and showed us all kinds of wonderful expressions. After shooting a roll of film, I suggested that we change the setup. François in a diaper, covered with a large bath towel, made for some beautiful images.

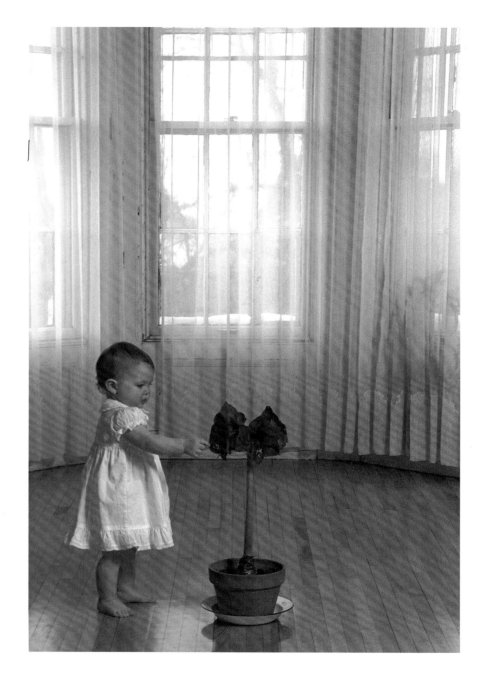

At fourteen months old, my neighbours' daughter, Maia, had discovered walking, and it was next to impossible to pose her, as she wouldn't stay still. When I brought my gear over, I noticed the amaryllis in the den and got the idea for this photograph. I set up one light, diffused by a large umbrella. Then I adjusted the power of the flash so the light would not overpower the scene but would allow the daylight to show through the window. Only when I was ready to shoot did we bring the amaryllis in the room. With a bit of coaxing, Maia went over and touched the flower. Click!

Maia's cheeks were very red that morning, so I opted to shoot with chromogenic black-and-white film (Kodak T400 CN). The warm hue was added at the printing stage.

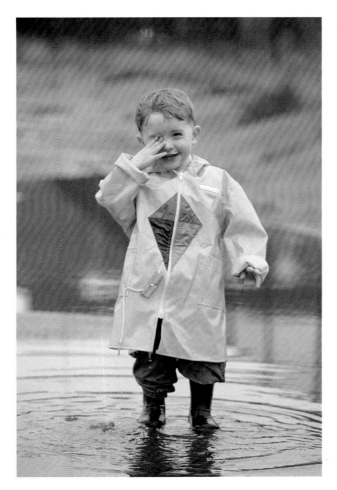 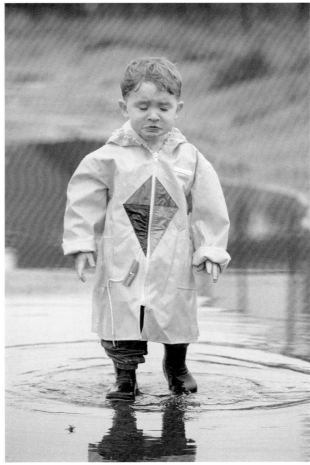

On a rainy summer day a few years ago, I asked Michelle if I could photograph Jaden, who was three at the time. The boy wore a raincoat and rubber boots, and we walked to an old street in our neighbourhood. I gave Jaden permission to jump in puddles if he felt like it. How often are kids allowed to do such a thing? Jaden started jumping and splashing as hard as he could, while I followed him around and captured his actions on film (400 ISO black-and-white). All of a sudden, he splashed water in his face and started laughing. Instantly, I clicked the shutter. A split second later, water got into his eyes. His expression changed dramatically, and he was on the verge of crying. Because I was alert, I clicked the shutter just before his father walked over to comfort him. This second image I could never replicate, and fortunately I was ready for it.

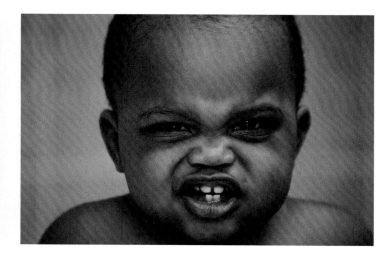

At ages three and four, Perry and Marcellus were a handful. After speaking with Cathy, their mother, I decided to take pictures of them in the tub, as they love bathing (or splashing away until there is no water left!). We also figured it would be easier to get good photographs when they were contained within a small area.

I set up one light (diffused with a white umbrella) against the far bathroom wall, making sure the stand was sturdy and out of the way. I measured the light with a flash meter before we brought in the boys. Once I was ready, we got the brothers into the tub, and I began to photograph. My original intention was to photograph them together, splashing away, but it was very difficult to find an angle from which both boys appeared to be looking at me. I felt the images looked contrived, so I began to take individual portraits. All of a sudden, Perry peeked out at me from behind the side of the tub. His face was partially obscured, and all the white emphasized his big wide eyes. I reacted instantly.

Marcellus, more timid at the time, did not seem very relaxed. In an effort to loosen him up, Cathy growled at him, and that did it! He started growling back, and we encouraged him. The unconventional close-up portrait of Marcellus growling is spontaneous, funny and very natural. The out-of-focus background of the bathroom tiles is harmonious in hue and not distracting.

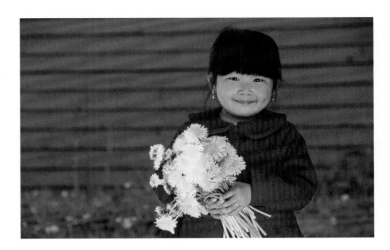

I asked my neighbours Bob and Sue if I could photograph their daughter, Mai Ling, for my portfolio. They agreed, and Sue invited me to choose the clothes Mai Ling would wear for the pictures. I chose simple, colourful clothes and scheduled the shoot for that evening at 7:00 p.m., when the light would be soft and warm (it was summer, and sunset was at 8:30).

I had two images in mind. The first was a posed portrait of Mai Ling, wearing a bright red coat and holding a bunch of the dandelions that were plentiful in our neighbourhood. When I noticed my little model squinting in the sunlight, I looked for a shaded area. Three doors down from us was a yard shaded by a two-storey house. The garage's blue shingles provided a nice plain background. I asked Mai Ling to stand in the shade, but close to where the sunlight was hitting. I placed my collapsible reflector on the ground in front of the child, observing its effect as it lit her face and produced catchlight in her eyes. I then began to photograph, coaxing different expressions from Mai Ling. Using my 80mm–200mm zoom lens, I took a roll of film, alternating between vertical and horizontal shots, and zooming the lens, shooting at different focal lengths.

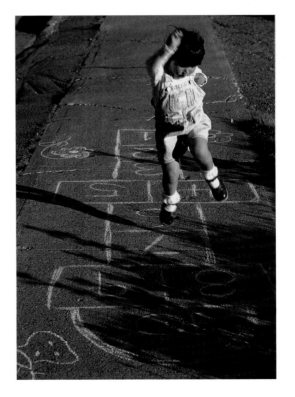

For the next shot, I wanted something more spontaneous. I had bought some chalk pencils earlier in the week. Hopscotch! We walked to an area where the sun was shining. I asked Sue to help Mai Ling draw the grid. Mai Ling was getting excited at the prospect, and she wanted us to play with her. We agreed to play, but only after I took the photographs. For the next ten minutes, I took pictures of Mai Ling jumping from one square to another. The photograph above stood out: Mai Ling is caught in midair and appears to be having a lot of fun. The red shoes are also great. And yes, we did play a few rounds of hop-scotch afterwards.

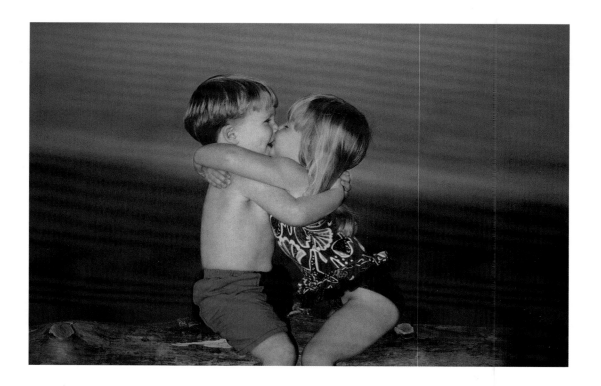

My friend and neighbour Michelle runs a private daycare out of her home. I asked if I could photograph her son Julian, and if she knew a girl close to the boy's age. Gina and Julian were both four and knew each other well, so we planned a photo shoot with them. I decided to photograph at a beach nearby and, as usual, picked a time when the sun was low and the light was warm. We gathered props—two canvas beach chairs, bright towels, sunglasses, colourful swimsuits, beach balls, a plastic pail and shovel—and headed out to Saint's Rest Beach, ten minutes away. We found an isolated spot with tall grasses and old driftwood logs.

With the light exquisite, I quickly began to photograph the two kids interacting and playing together. The water in the Bay of Fundy is extremely cold, so my focus for this shoot was the sandy beach. Julian and Gina danced in the sand, walked hand in hand, collected shells and pebbles and sat in the sun. I shot most of the pictures on a tripod, with an 80mm–200mm f2.8 lens. I took a few handheld shots when the children were dancing and running along the shore.

When there were about ten minutes of sunlight left, I posed the children on one of the weathered logs. I used the longest range of my lens and photographed at f5.6 because I wanted to blur the background considerably and give my models prominence in the photo. At one point, I asked Gina if she would kiss Julian. She was enthusiastic about this request, and Michelle and I cracked up at her display of affection. It was unplanned and very spontaneous, and it turned out to be my favourite image made that evening.

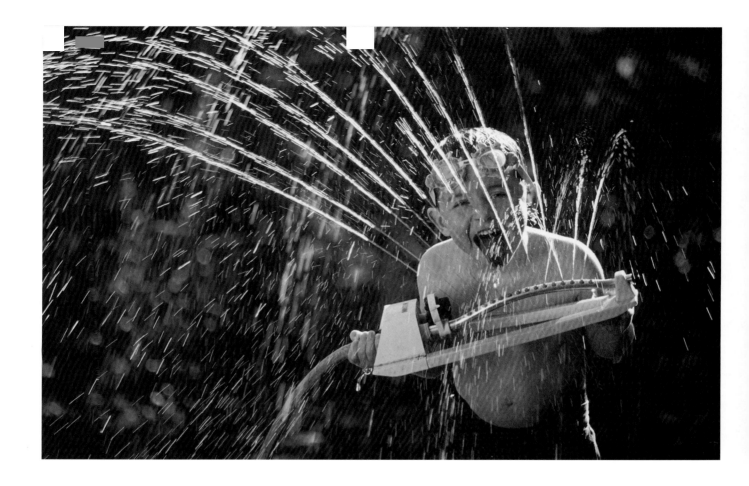

Last year, we were experiencing a nice hot summer day (very unusual for Saint John), so I called Michelle to see if I could photograph Jaden. Because I've photographed him many times, he is very comfortable around me and my camera. We set up behind the house and I had the garden sprinkler going. The effect of the backlight on the water was wonderful, making every drop stand out against the dark, out-of-focus background. Jaden enjoyed running through the jets of water. At one point during the shoot, he grabbed the sprinkler and started to drink from it. Unplanned and spontaneous, this was the shot.

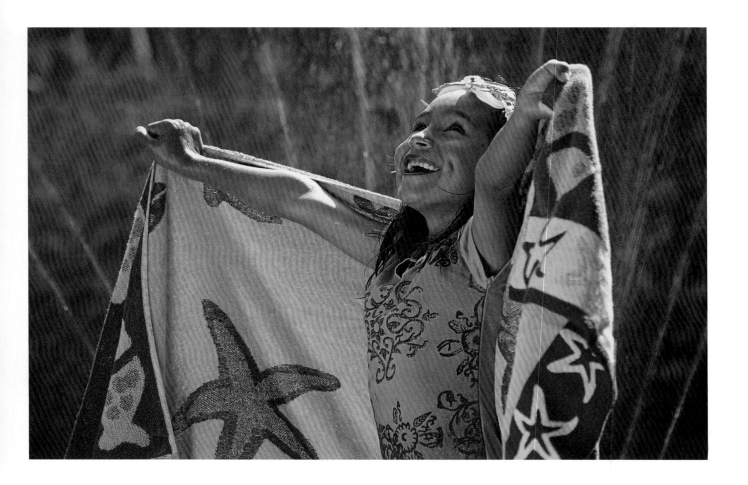

Having had much success with my garden sprinkler, I took a different approach with this photograph, using the backlit jets of water as my background. I used a large piece of white foam board as a reflector, and positioned it in front of Jasmine, my seven-year-old model. Her only instructions were to have fun with the water. I provided her with the colourful towel and the inexpensive goggles, and encouraged her to play and not pay any attention to me. Standing way back with my 80mm–200mm f2.8 zoom lens, I took photographs as she twirled around with the towel. In this image, Jasmine's exuberance conveys the child's free spirit.

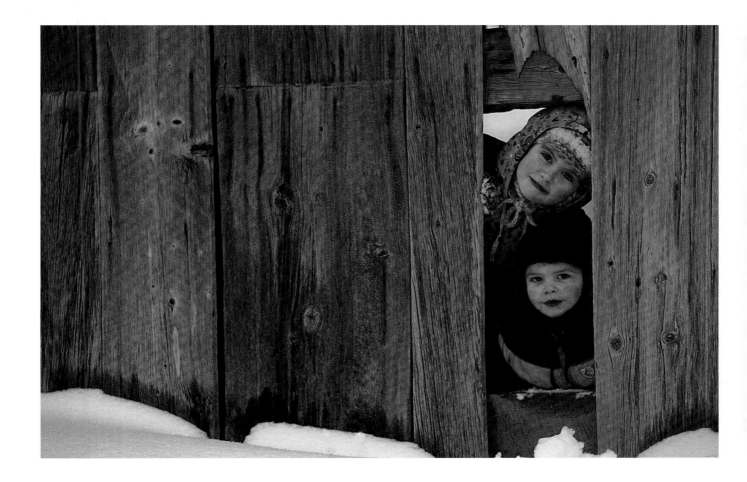

I've been photographing Audrey since she was a year old. Her younger brother, on the other hand, is quite a character and never let me photograph him until I showed up one day with two sets of prints of Audrey. As we were all looking at the photos, out of nowhere, Richard said, "It's my turn to be in pictures." It was a beautiful winter day, cloudy, bright and not too cold. We put our coats on and went outside. Knowing that Ann, their mother, would like a shot of the two of them together, I looked for a spot to photograph them. There was a missing board on one of the barns, and I figured the kids could look out of the hole. I helped Audrey and Richard through the opening and then posed them as they looked out. On my next visit, Richard was glad that I had pictures of him as well as his sister.

People spend a large part of their lives working, and it's not uncommon to take portraits of individuals at work. The posed image might show someone wearing work clothes in the surroundings where they do their job, while the more candid approach might show the person actually working, giving an insightful look at what they do to earn a living.

Many of my editorial assignments involve photographing people at the workplace. Years ago, I had the opportunity to photograph a lobster fishing crew on one of its daily outings. It was early in May, and we set out to sea at 4:30 in the morning. It was cold and still very dark. The men started bringing in their catch while I waited down below for enough light to expose my film. I joined them on deck once there was enough colour in the sky to photograph silhouettes. When the sun finally cleared the horizon, I took pictures of the fishermen bathed in warm light as they raised their traps, emptied the contents and put in fresh bait before dropping them back into the ocean. At break time, I took a few individual portraits, alternating backgrounds between the weathered vessel and the open sea. For the next day, I had a bit of the spins from the rocking motion of the boat, but it was a very educational morning, and one I always remember when I eat lobster.

When photographing people at work, you want to incorporate enough of the surroundings to give the portrait a sense of place. Think of a lifeguard sitting high on his lookout station, a doorman standing in front of a hotel or a construction worker at a new building site. The places where we find and photograph these people are very relevant to their portraits.

Sometimes, a few props and your subject's outfit will be sufficient to convey what he does for a living: a taxi driver and his cab, a chef wearing a tall white hat, a farmer with his tractor. Think of all the people in recognizable uniforms: cops, nurses, waiters. These items of clothing are very descriptive, and they become an integral part of the portrait.

I could not resist the urge to include this image in the book. Obviously, I did not take this photograph of myself. It was taken by my partner. I needed a publicity shot and wanted a photograph of myself at work. I asked Parker if he would take the shot. We set out to take the picture at a large pond on my friend Terry's property. We arrived when the light was warm and soft. I went into the pond with one of my cameras, lowering my body until I had water up to my shoulders. Under Parker's direction, I posed until the entire roll of slide film was exposed. This image is a favourite of many people, including me. Job well done, Parker!

André is a disc jockey in Berlin. He wanted a publicity photo of himself and asked if I would take his portrait. DJs have a high profile in Europe, and I wanted to do something different and creative. We broke one of his older records for inclusion as a prop. I photographed in black and white with the knowledge that I would solarize the photograph (a special effect achieved in the darkroom in which the lights are turned on briefly while the exposed photographic paper is in the developer). The background was a small piece of metal flooring that was lying around his apartment. Although I took some images with André looking at me, I felt that this photo, with his eyes closed, put the emphasis on the sense of hearing rather than that of sight.

While doing work for Tourism New Brunswick, I was asked to take a few images of lobster fishing on the Acadian Peninsula. Someone I knew offered to take me out on his boat, from which I could photograph. Having made arrangements for the shoot the previous evening, we followed a local fisherman for a couple of hours one morning, setting out just before sunrise. I like the casual feel of this environmental portrait: the light is warm and beautiful, and the expressions are amiable.

President's Choice Magazine commissioned me to take a portrait of this chef at one of New Brunswick's finest hotels, the Algonquin. Rather than shoot in the commercial kitchen, I opted to photograph outside on the beautiful verandah. There was plenty of reflected light, but I used a reflector to fill in the shadows. Using a 70mm–300mm zoom lens, I backed away so I could blur the background nicely, shooting at close to 300mm. Note that the chef, Willie, is off-centre, and there is ample room for type at the left of the image. The clothes provide sufficient information about what this man does for a living.

Saturday Night magazine hired me to take a portrait of a tuna fisherman in Nova Scotia. I met him at the wharf where his boat was tied up. After a brief introduction and a bit of small talk, I looked for a place to take his picture, trying to visualize a background that suited the story. His boat, an obvious choice, was a good place to begin. Shooting with my medium-format camera, I took a series of portraits with the boat as my background. I rewound the film, not feeling too enthusiastic about what I had just photographed. Then I noticed one of the harpoons along the side of the boat's cabin. I thought, this is it—this prop will make the shot! We moved to the edge of the dock, where I posed the fisherman holding the harpoon in an oblique position to add a dynamic line in the photograph. A strong shape was also created when I asked the man to spread his feet. We went through a series of expressions, and the more serious poses seemed to suit the tone of the article best.

A great time to photograph people is when they are resting: on a weekend, at the cottage or on holiday, lounging by the pool or walking along the ocean. At these times, people are most relaxed and, very likely, more cooperative.

It's important to recognize appropriate times to photograph people. We all have good and bad days. It's best to photograph people when they're not tired and are in good spirits. I recently visited a close friend, hoping to photograph him with his son. When I arrived, he was tired, had a backache and was somewhat grumpy. I refrained from mentioning what I had in mind, as I knew instinctively that the timing was wrong. A couple of days later, off work for the weekend and feeling more rested, my friend played with his son in the snow while I took pictures of the two of them.

When I'm working at the computer (writing a book perhaps!), or photographing on assignment, my stress level is elevated and my body is tense. As soon as I step into the garden, my nerves calm down. I begin to relax, and it's as if I've become another person. Find out from those you want to photograph what they enjoy doing or where they like to go to unwind. You can plan your photo session around that knowledge.

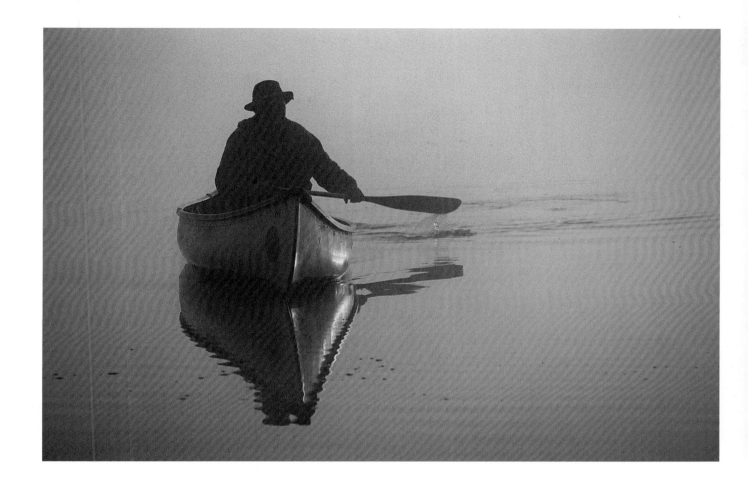

I decided to photograph my friend Terry where he's most comfortable: in nature. I felt this portrait captured the essence of the man, his love of water and his fondness for canoeing. The sun had just cleared the top of the mountain, bathing the mist in a warm hue. Using my 70mm–300mm zoom lens, I composed the image, making the canoeist fairly large in the scene, and made sure he was not dead centre. With a scene like this one, it is wise to bracket (see page 17) to make sure you get the right exposure.

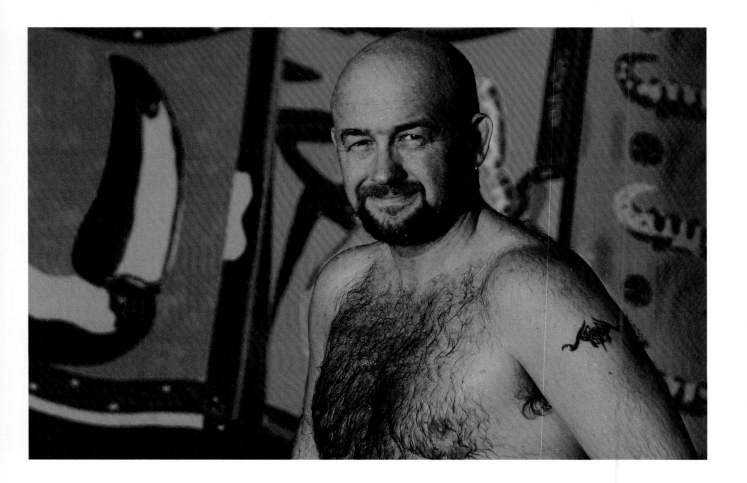

Parker and I recently took a trip to Costa Rica. I made a point of photographing every day at the "magic hour," an hour or so before sunset. On this particular day, I was shooting at a beach in Manuel Antonio while Parker was in the water, probably bodysurfing. I shot a few portraits of the locals while waiting for sunset. I also photographed various details: colourful fabrics blowing in the wind, beach chairs and umbrellas, palm trees. When Parker suddenly showed up, the light was wonderful, so I asked if I could take a quick portrait of him. I used the colourful fabrics from one of the souvenir shops as the background and finished my film with the last four frames.

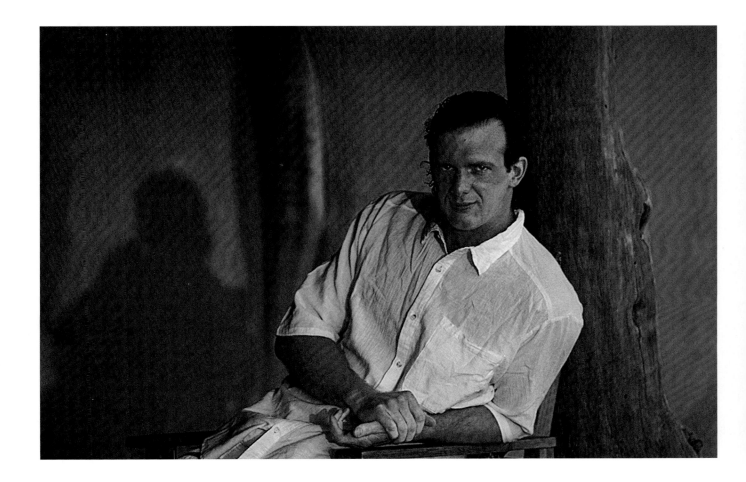

On a trip to Namibia with a few friends, we stayed at a very nice lodge near Sossusvlei, part of the Namib Desert. We had spent all morning and part of the afternoon photographing the sand dunes. After a rest at the lodge, none of us had the energy to go back to Sossusvlei for the evening light and sunset. We opted to stay by the pool, rest some more and have a glass of wine. As the sun neared the horizon and the light softened and warmed up, I was itching to photograph, so I asked Jonathan if I could take his portrait. Moments later, I was taking shots of my friend, first in the pool and then against the ochre wall of the hotel. I asked him to sit in a chair and lean forward on its arm. He appeared very comfortable and relaxed in that position. The front light was warm on him and created the shadow on the wall behind him. The slightly oblique line of his body added a nice line to the simple composition. Once the light was gone, we headed for the bar.

I photographed my nephew Joey, who's now a teenager. I wanted him to feel comfortable in front of the camera, so I decided to photograph him doing one of his favourite activities, skateboarding. Shooting with my digital camera, I took a series of action shots as he did his thing, jumping high up in the air. The photo above is a panned image, shooting at $\frac{1}{20}$th of a second. For the photo on the opposite page, I used a wide-angle lens and shot from a low position to exaggerate the height of his jumps. I also used a flash on my camera to freeze the action in mid-air, balancing daylight with the burst of light from the flash.

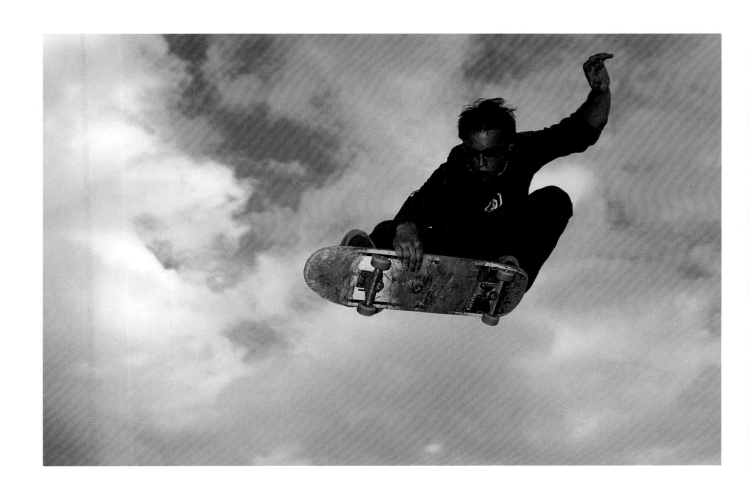

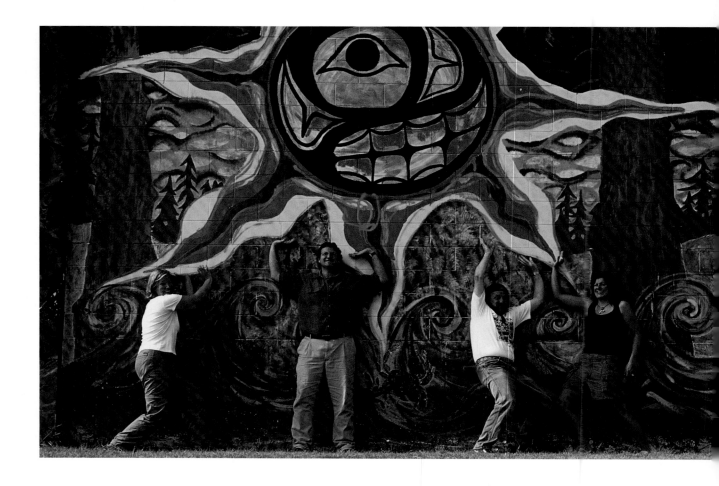

Recently, three good friends and I vacationed in the Queen Charlotte Islands in British Columbia. We spent some time in Old Masset, and it dawned on me that we should have a group photo of ourselves as a souvenir. By chance, I had earlier noticed a colourful mural in town, so we drove to that location to take the photograph. I asked everyone to act goofy and interact with the graffiti. With my camera on the tripod, I composed the image and set the self-timer, then quickly joined my friends for our informal portrait.

PHOTOGRAPHING
PEOPLE AROUND
THE WORLD

Working for magazines such as *Destinations*, *En Route* and *Canadian Geographic*, I've had the privilege of photographing people around the world. It was not easy at first, but it has been a rewarding part of my life.

In the early days of my travels, I was extremely shy. So when I photographed strangers, it was with a very long lens, because I did not want to be noticed taking their pictures. When the time came to make the rounds showing my travel work to art directors, they made the same comment: "We like your work, but we want to see these strangers' faces." It made me realize that if I wanted to be a travel photographer, I would have to overcome my shyness and start bringing back portraits showing faces and capturing expressions.

On subsequent trips, with a revised attitude, I made a point of taking pictures of people every day. In markets, on the street or in busy town squares, there I was, aiming my camera at strangers as they went about their business. I often missed shots because of my hesitation, but the frustration that ensued helped me to react more quickly when the next opportunity presented itself. My confidence increased slowly as my portraits improved, and my travel portfolio reflected my newfound boldness.

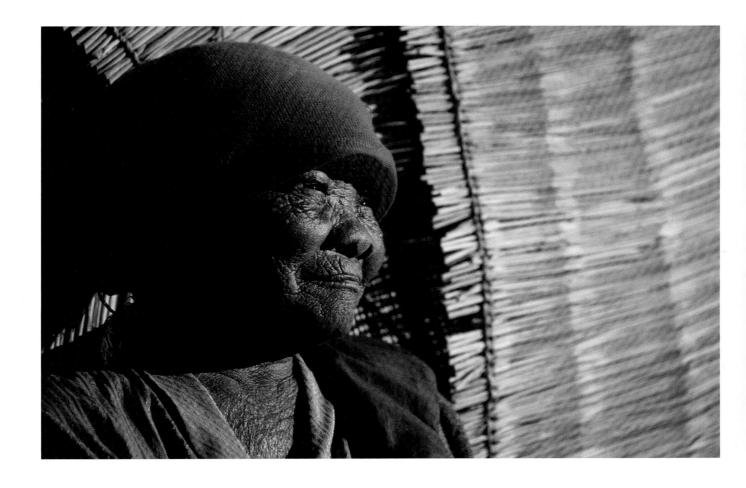

On a visit to South Africa, my friend Colla Swart took a group of us to the small village of Nourivier so we could photograph some of its residents. I was really taken with the character in this woman's face. This lady has lived. The light was warm and lovely on her face. Suddenly, as she looked away, the sun sparkled in her eyes, and it looked like magic. I clicked the shutter before that instant disappeared. Although I photographed haunting abandoned houses in Namibia and the majestic sand dunes of the Namib Desert, it is this posed portrait that brings back the wonder of that exquisite continent.

What to Bring with You

When you travel, it's always difficult to decide what photographic equipment to bring with you. The adage "less is more" is beginning to sink in, and I now try to carry as little as possible, without omitting an item I may really need. A checklist can be very useful, especially if you are anything like me and pack at the last minute. Below is a list I consult before going on a trip, which you can adapt to reflect your own needs.

For film cameras

- Two camera bodies: I alternate between the two every other day—if one malfunctions, at least I'll still have half the pictures I took.
- Lenses: 24mm–135mm f3.5, 80mm–200mm f2.8, 100mm–400mm f5.6.
- Photo vest: I like my equipment to be easily accessible, so I prefer a photo vest to a camera bag. And if someone is trying to steal my equipment, they'll have to get the vest off me first.
- Film: I always bring more than I think I'll need. Quite often, you can't find your film of choice abroad—and if you do, it can cost twice what you'd pay at home. I use an average of eight to ten rolls per day.
- Filters: Polarizing filter, 81A warming filter.
- Batteries: Always have extras, both in a camera bag and in your photo vest.
- Camera flash: Don't forget fresh batteries for your flash too!
- Tripod: When I fly, I pack my tripod in a hard suitcase, as they can easily be damaged in transit.
- Reflector: For photographing people, I'll pack a 48-inch (120 cm) reflector.

For digital cameras

- Two camera bodies: See above.
- Lenses: 17mm–35mm f2.8, 35mm–80mm f2.8, 70mm–300mm f5.6.
- Batteries: Bring extra—digital cameras use a lot of power, and there's nothing more disappointing than having your battery run out just when you're getting great shots. Don't forget your battery charger. One

battery can be recharging while you're out using the others.

- Tripod: See above.
- Large-capacity memory cards: Bring extras, especially if you won't be able to download your images to a computer while you're travelling.
- Laptop computer: Make sure to bring a 220-volt electrical converter if you're travelling in Europe. And don't forget the cable to attach your camera to the laptop.

Airport x-ray scanners are always a big concern. Never pack film in your checked luggage; bring it with you in a carry-on and ask for hand inspection. You can facilitate this process by using clear plastic containers for your film or, better yet, by placing it in a resealable clear plastic bag. If you are refused hand inspection, don't panic, as the carry-on x-ray machines are deemed safe for film. In my twenty years of experience, I've never had film fogged or ruined by an x-ray scanner.

Taking notes and journaling

Journaling and taking notes will enable you to caption your photos accurately and create a photo diary of your travels. It's easy to forget details after a long trip abroad. When you photograph a place, a person or an interesting detail, write down as much information as you can. I often photograph street signs, restaurant signs and monument descriptions and include these photographs in my photo albums. These markers help keep the sequence of my travels fresh in my mind. When you get home, a photograph of a street sign, for example, will help you remember where you shot the images that immediately follow it on the roll, and, with the visual reminder, other details of the events will likely come pouring back to you, even weeks later.

In your journal, you can describe how you're feeling, your impressions of the images you are capturing, and any details you may forget by the time you get home. Simple or grand, write down your experiences, recount meeting special people and describe magical moments. Reading your journal years later, you will be able to relive all the events of your journey.

A couple of years ago, a good friend surprised me by showing me a collection of postcards I'd sent him over many years of travelling. There were more than eighty postcards, and my first reaction was, "Wow! I've been to all of these places!" It was only when I started to read what I'd written to him ten or fifteen years before that I realized how much I'd forgotten about my travels. The few words I jotted down years ago on the back of those old postcards brought back a wealth of memories.

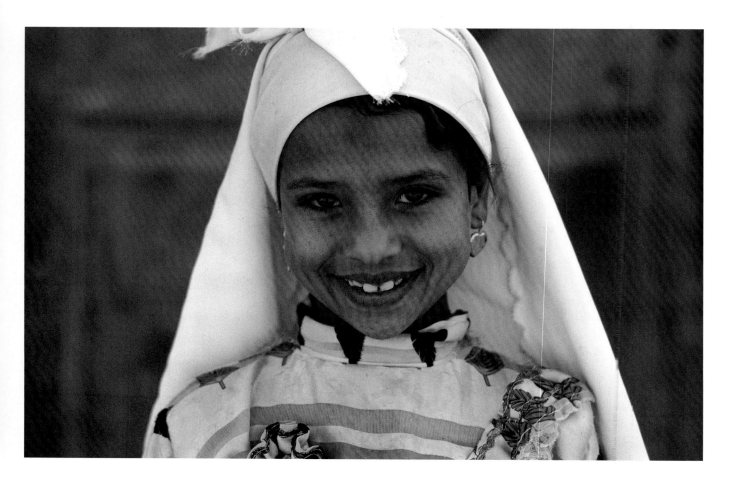

In 1990, I had an assignment that took me to Egypt for a month. With two camera bodies, three lenses (24mm–70mm f2.8, 80mm–200mm f2.8, and 300mm f4), a tripod, a couple of filters (an 81A warming filter and a polarizing filter), lots of batteries and two hundred rolls of film, I was ready to illustrate a story on the remote oasis of Siwa.

One day, I was wandering the small alleyways of Shali, a small town made up of a cluster of mud houses that cling to a steep hill, when I encountered a young girl. A huge smile lit up her face. I reacted quickly and took a few close-up portraits. I used my 80mm–200mm zoom lens and shot fairly wide open to ensure a blurred background. I liked how the scarf covering her head created a triangle in my composition. Before walking away, I reached into my vest pocket and handed her a pen, a gift that seems to be a favourite of children around the world.

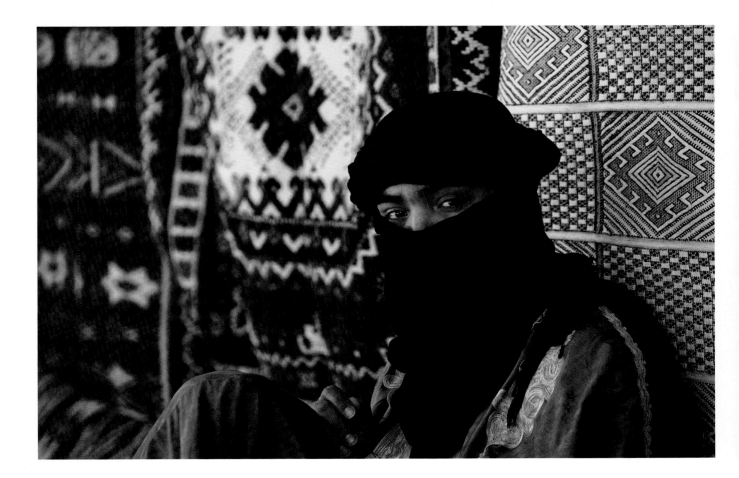

On one of my trips to Morocco, I took the time to get to know the people I wanted to photograph. This was made easier because French—my first language—is commonly spoken there. In the small village of Tafraoute, I spent quite a while with a young man selling carpets. We had mint tea while Brahim told me about different rugs and explained the meaning behind the patterns that decorate them. I ended up buying two kilims. As he wrapped them up, I asked if I could take his portrait. He agreed. I took my time and posed him in front of his shop, with the colourful display of carpets as my background. To ensure sharpness, I secured my camera to the tripod. Using my 80mm–200mm zoom lens, I took photographs of Brahim pouring mint tea, and also some close-up portraits. For the final shot, I asked him to wear his turban as nomads don them in desert storms. Before I left, Brahim invited me to his wedding, which was taking place the next month. I politely declined, but was honoured to be asked.

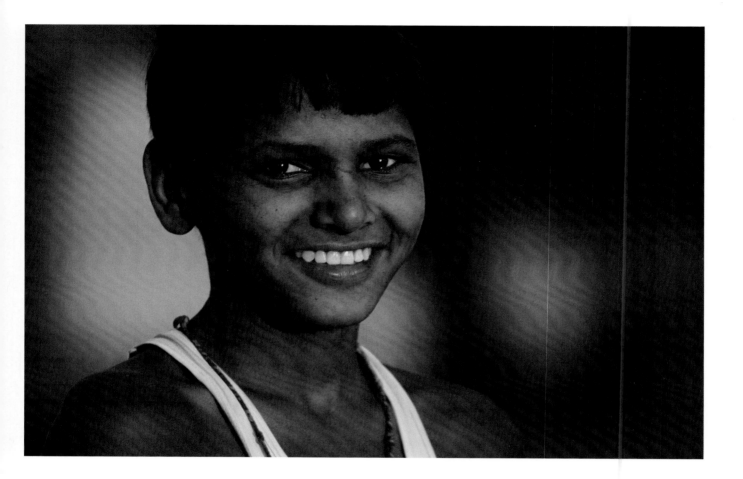

On this evening in Rajasthan, India, the sun was low in the sky, and the light was beautiful. My urge to photograph was strong, so I asked my driver to pull off to the side of the road. I left my tripod in the car, as I did not want to be weighed down by too much equipment, but I had a couple of lenses in my vest. I started walking up a dirt road that led to a couple of houses. India is amazing in that people seem to appear out of nowhere. It wasn't long before a couple of kids came over to see who I was, their eyes full of curiosity. Minutes later, more children showed up. Using my wide-angle zoom lens (28mm–70mm f2.8), I took some photos of the small group surrounding me. Then I switched to my longer zoom (70mm–300mm) and shot individual portraits. With only a few minutes of sunshine left, I photographed this young boy. His sparkling eyes and brilliant smile make the portrait come alive.

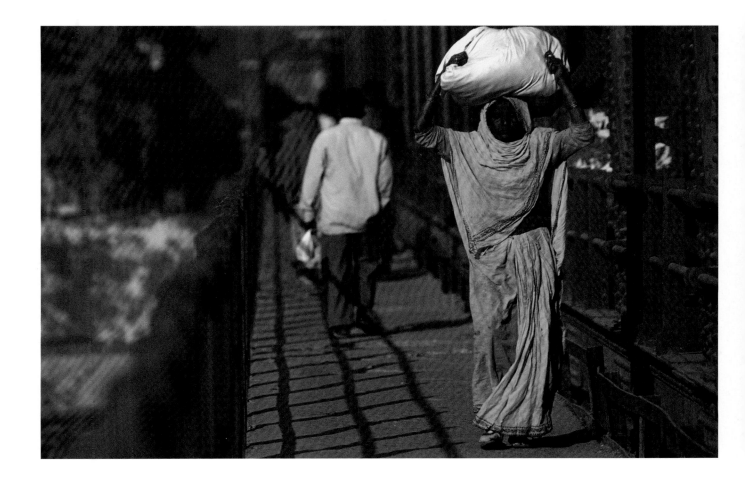

Recently, in Agra, India, I was crossing a bridge and was overwhelmed by the number of people coming and going. It was a great place to take candids. I steadied myself against the side of the bridge and put my 100mm–400mm image-stabilized zoom lens on the camera. Shooting film with an ISO of 100, I was able to handhold my camera and shoot between 1/180th and ½₅₀th of a second at f8. For the next thirty minutes, I

aimed my camera at the people coming towards me: women draped in colourful saris, some carrying bags on their heads, elders walking slowly, youngsters on bicycles, couples holding hands. Most of the people looked straight at me, although a few looked away or down at their feet. It was nothing less than fascinating and a thrill to watch and to photograph.

When travelling, I often feel a strong need to photograph the locals. A stranger's face can be so expressive or so full of character that it seems to tell a story. And the clothing they wear often seems so exotic to me—the bright-hued saris of women in India, the long jellabas of Egyptian men—yet it speaks volumes about the environment and culture of the people wearing it.

When someone's look arrests me, I'll approach him and ask to take his picture. As daunting as it may seem, it's actually very easy to do. He will often be flattered. The worst that can happen is that he will refuse, in which case you can just walk away and approach someone else.

People who work in the service industry can be the easiest to approach. They often speak some English and are attentive to foreigners' requests. Think of servers in restaurants, doormen, bellhops, taxi drivers, market vendors. Then there are those in the entertainment business: the Mexican mariachi band looking to serenade you, the young Moroccan girls who want to tattoo your hands with henna. Remember, they came to offer you a service, so why not ask if you can photograph them? If they agree, you can offer a gratuity as a token of your appreciation.

Driving through the Atlas Mountains in Morocco, my partner and I stopped at a roadside restaurant for lunch in a remote village. We ordered tagine, a local dish, and two Cokes. As we waited for our meals, a man carrying a banjo headed in our direction. I said to Parker, "Oh no, here we go!" As the stranger played and sang his song, I realized what a great opportunity this was. When he was finished, I tipped him for his song and asked if I could take his picture. He agreed, as I knew he would, and for the next ten or fifteen minutes I had a very cooperative subject. The ice had already been broken, and both of us were relaxed. I took my time posing him in the doorway of the restaurant, where the light was diffused and plentiful, choosing a blank wall as the background. Feeling unrushed, I took portraits of the man and his banjo, as well as tight close-ups of his face, full of character and piercing dark eyes. I felt a rush of excitement after such a good photo shoot.

Here are a few suggestions that may help you in your approach: If you speak the language, engage the person you want to photograph in a bit of conversation. Introduce yourself, telling her your name, where you are from and why you are visiting her country. If she seems interested in what you have to say, you can divulge a bit more, perhaps saying something positive about your time here. You can then ask a few questions to learn more about her. This will break the ice, and you'll feel more comfortable about asking to take her photograph—and she may be more receptive to letting you do so.

If you're travelling to a place where you don't speak the language, make a point of learning a few words, especially "Can I take your picture?" and "Thank you." This shows people that you've put some effort into trying to communicate with them. I learned the phrase "*Borro nazes para photograhia?*" before going on a cruise to the Greek islands. It worked well every time I used it, making it possible for me to capture beautiful portraits. One minor drawback was that people started to converse with me in Greek before they realized I did not understand what they were saying. Write these few words down on a piece of paper, and include a phonetic rendering that will help you remember how to pronounce them. Keep it in your wallet, just in case. If you don't know even these simple phrases, smile a lot and point to your camera and your intended subject. He will know what you want and will nod in an approving manner, or not.

If you're using a digital camera, don't hesitate to show the people you are photographing their pictures. They will likely be excited, and will feel more connected to what you are doing. In return, they may allow you to take more photographs, perhaps shooting in a different setting, where you can try to capture various expressions.

In some countries, you'll encounter people who will ask for money in return for letting you photograph them. It's up to you to decide whether to tip. While some photographers are against it, I feel a small contribution is a way to give back to people willing to take time out of their busy day to pose for you. I usually give adults about five dollars. When strangers ask for outrageous amounts, I just walk away. When it comes to children, I don't encourage giving money, but small gifts such as pens, notepads or balloons will bring big smiles to their faces. If possible, travel with a Polaroid camera: the ability to give people an instant picture is a wonderful icebreaker and makes a wonderful gift. You may be surprised at how many candidates will want to pose for you. Be careful with such a camera around groups of children. In Jamaica a few years ago, I started a riot among school children as they fought for the few Polaroids I snapped of them.

If you agree to send pictures to those you've photographed, make sure to keep your promise. Doing so will benefit photographers who come after you.

The Model Release

Where and when can you use photographs of people? This question is getting harder to answer. If at all possible, you should always ask the people appearing in your photos to sign a model release. This is a legal document, an agreement between you and the person you've photographed, that gives you the rights to the pictures. Have this form ready and get it signed before you begin to photograph. In order to bind the contract, you must

give something (photos, money, etc.) to the person signing the release.

A model release should include your name as the photographer and a statement such as this: "For value received (_____), I hereby transfer to the Photographer all rights whatsoever that I have in the photographs that he/she has taken of me. I consent to the use of the photographs for all purposes whatsoever (including without limitation, television, publications and any trade or advertising purposes). The photographer may transfer his/her rights in these photographs to others and they may rely on this consent." Your subject should both print and sign her name and should include her address and the date the document was signed. Whenever possible, get someone to witness the signature. If your subject is under eighteen, you must have at least one, and preferably both, of her parents sign the document, with a statement that they are the parents or legal guardians of the minor named in the release and that they approve of the arrangement.

Any time a photo will be used for advertising, a model release is a must. If a photograph of a person is published as editorial content in a book or magazine, and the person is depicted in a positive way, there should be no need for a model release. When a photo is used in a negative or derogatory way, a model release will not always protect you. In this day and age, lawsuits are common, and it can be very costly to defend yourself, even if you did nothing wrong. An ad in a newspaper once caught my eye. It had an image of a teenage girl in a school uniform holding a stack of books. The headline was something like "Teens and Breast Implants." Because of what the headline implies, my first thought was, does this girl know what her picture is being used for? This can be a dangerous situation, even if the photographer has a model release.

If you don't have a model release, be careful when you agree to let someone publish your work. If you have one, make sure you know what the picture will be used for.

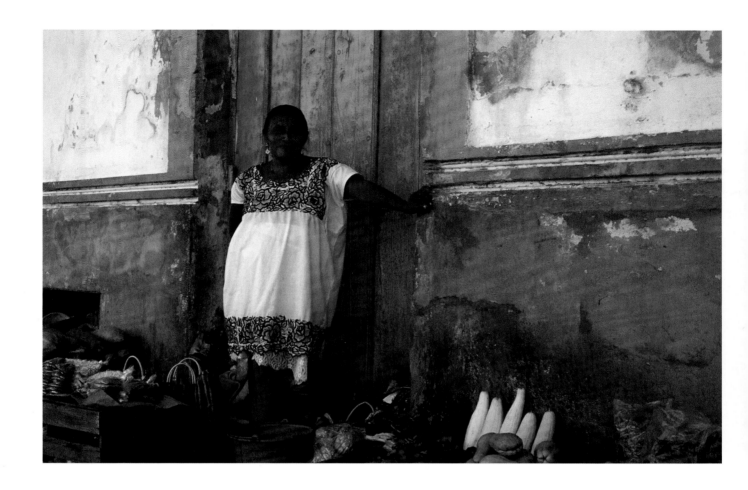

While travelling through the Yucatan Peninsula in Mexico, I spent an evening in Valladolid. Up early the next morning, I set out to photograph as the town came alive soon after sunrise. People were setting up small stalls on the sidewalks near the main square, selling everything from fruits and vegetables to clothes, leather belts, dishes and pots and pans. I saw this lady by a colourful weathered wall and rushed over to her. When I pointed to my camera, she hesitated, but after a bit of persuasion, she agreed to let me take a few pictures. Before walking away, I gave her a small tip.

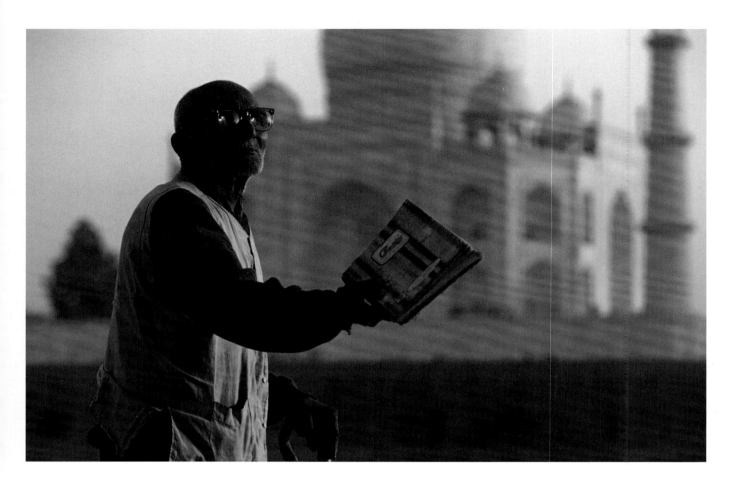

In Agra, India, I had just photographed the Taj Mahal at sunrise and was on my way back to the city centre. I walked past this elder, who was collecting donations for his shrine nearby. I donated a small amount and seized the opportunity to ask if I could take his portrait. He agreed to pose for me. I took a few frames, using the Taj Mahal as the background. Suddenly, he handed his visitors' notebook to someone close by, and I reacted, clicking a few frames. The light was warm on his face, and his extended arm added dynamic to the portrait.

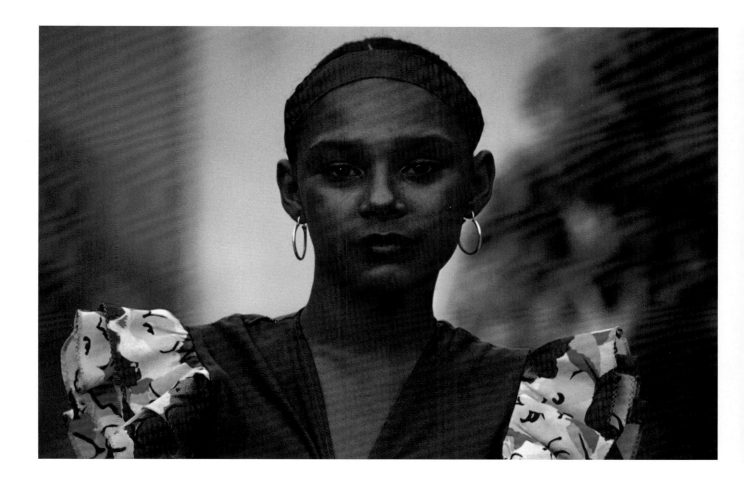

One evening in Cartagena, Colombia, I was having dinner with friends in an outside restaurant when a group of young dancers showed up for a quick performance. While they were dancing, my friend Olga, who speaks Spanish, suggested that we ask to photograph them the next day, early in the evening to take advantage of the beautiful light before the sunset. I gladly agreed, and Olga went over and arranged for them to meet us at 5:00 p.m. the next day.

Although the four dancers showed up a bit late, there was still enough light for us to photograph. Using a large aperture to blur the background, I took individual portraits of each of them, then took a group photo. Finally, as the light was waning, I shot some blurred images (shooting at a slow shutter speed between 1 second and 1/4th of a second) of them dancing. We tipped them and, as promised, sent them a good selection of photographs.

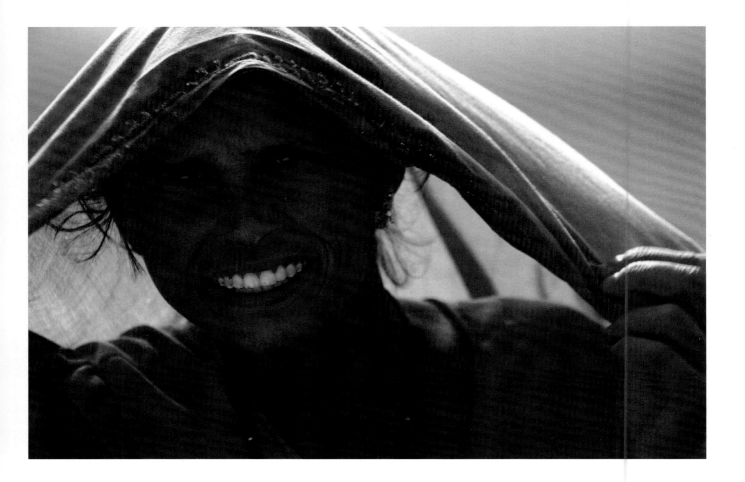

While in Rajasthan, India, I noticed some women and children working in the fields and decided to try to get a few photographs. I walked up to them and, with the usual gestures, attempted to convey my wishes. I did not seem to be getting anywhere, so I asked my taxi driver to communicate with them on my behalf. He informed me that they would let me photograph them in exchange for some money. After agreeing to an amount, I photographed the children first.

When I raised my camera towards this woman, she pulled her veil over her face. My driver again came to the rescue, and she briefly lifted her veil. I took a few shots before she turned and walked away. Because the sunlight was strong, I used backlighting for this portrait. I was very thankful for my taxi driver's help: first he convinced these people to pose for me, then he held my reflector, which filled in the shadows, reduced the contrast and added catchlights to the eyes.

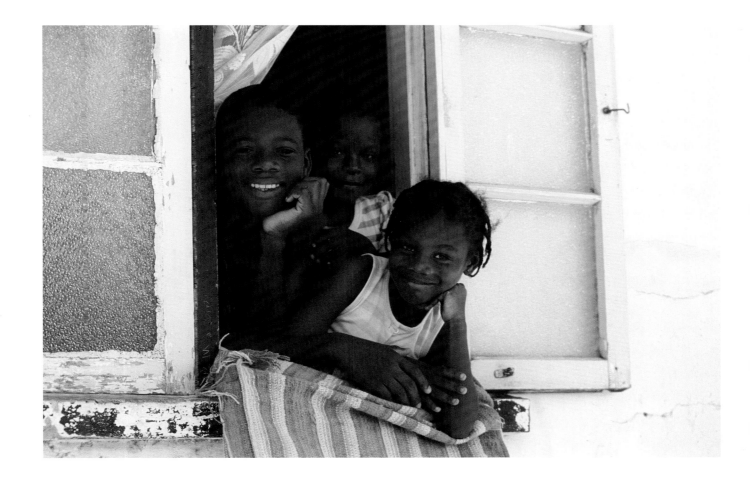

On one of my trips to the Caribbean, I was wandering in a small village in the Barbados, hoping to find some people who would pose for me. A young girl watched from a window as I walked past her house. I smiled at her and pointed to my camera. When she disappeared, I concluded that she did not want her picture taken, but suddenly she emerged with a sibling or friend, and they began to pose for me. Excited, I reacted instantly and took a few shots. The window was in the shade, and the reflected light from the sidewalk and the road was more than enough to expose my 100 ISO slide film. Eventually, her big brother joined in, and I photographed the three of them together. Afterwards, feeling very happy about the shoot, I knocked on their door to get their address so I could send them a few photographs.

When someone agrees to let you photograph them, work as quickly as possible. The person may feel awkward and intimidated if you take too long setting up the shot. Zoom lenses are great because they allow you to shoot close-up portraits as well as photographs that include surroundings that tell a story about the subject. There are two zoom lenses I like to have when shooting portraits: a 24mm–135mm and an 80mm–200mm, both fast lenses at f2.8. Work with a tripod as much as possible to ensure sharp, well-composed photographs.

When you have a cooperative subject, try to take a variety of images. With a zoom lens, you can alter your shooting range without moving. Start wide and move in tighter, gradually eliminating some of the background and creating the composition you want. Don't feel shy about shooting close-up portraits; these are often the most interesting. Use the longest range of your zoom lens (135mm or 200mm) so you won't feel like you're right in the person's face, and neither will he. If it's midday and the light is harsh, the use of fill flash will reduce contrast by filling in shadows. Don't overlook the possibility of moving to a nearby spot in the shade.

It was early morning, and I was driving to a weekly market in a small town in Oaxaca, Mexico. The sun had just risen, painting the landscape with a warm hue. In the distance, I noticed a man working in a field. I brought the car to a halt and grabbed my camera, fitted with my favourite travelling lens (80mm–200mm f2.8). When I reached the man, having forgotten how to say "Can I take your picture?" in Spanish, I pointed to him, then to my camera. He understood and, in turn, made his own gesture, rubbing his thumb and index finger together. I reached into my pocket and give him a fifty-peso bill (about five dollars). I proceeded to take several shots, starting wide for an environmental portrait that included the field and his horse and carriage. As I zoomed closer, he became the centre of interest, and zoomed until his face filled the frame. I'm certain he did not expect me to take so many photos, but when I pay to photograph someone, I make sure I get the shot. As I walked back to the car, I took one last shot encompassing the towering mountains in the background.

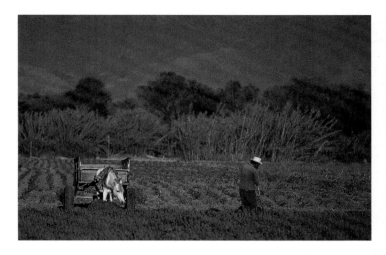

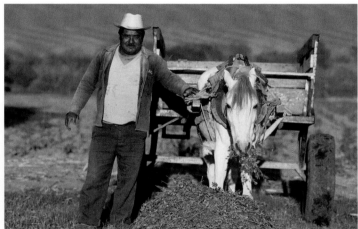

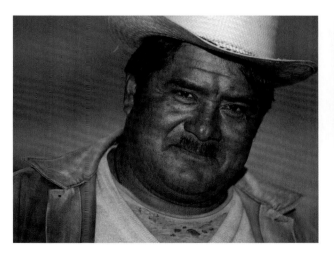

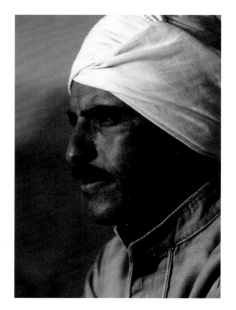

While visiting the pyramids in Cairo, I hired a guide with a camel. My intent was to photograph them, rather than be guided or ride the animal. I spent the early part of the afternoon exploring the enchanting majestic structures. When the light became favourable for taking portraits, I took a series of pictures of my Egyptian guide and his camel. I shot tight frontal and profile close-ups (vertical and horizontal), head-and-shoulder portraits and photos of the guide leading and riding his camel, with the pyramids in the background. I kept shooting until sunset, then took a couple of silhouettes. I made my money go a long way.

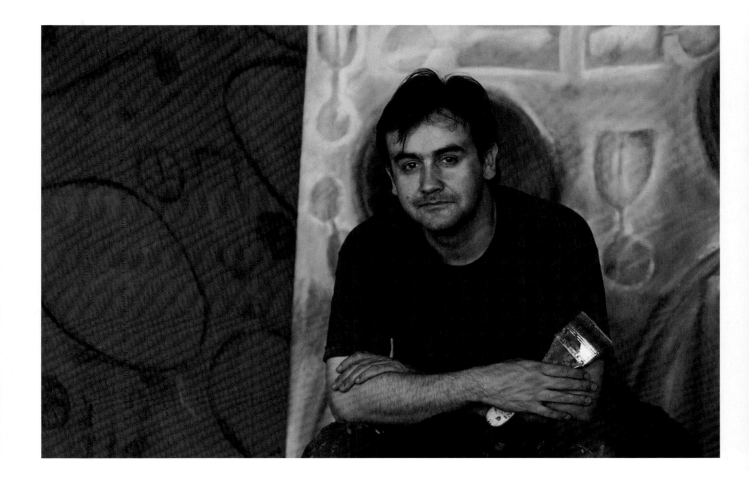

Didier is an artist in Oaxaca, Mexico. His style reminds me of Miró, and I was instantly seduced by his work. After purchasing two large canvases, I talked with the artist and his mother until their gallery closed. They invited me to their house for dinner that evening, and I accepted without hesitation. We enjoyed wine and pizza and shared good conversation. Before leaving, I asked Didier if I could take his portrait. Flattered by my request, he graciously agreed. Using two of his paintings as the background, I posed him holding a paintbrush, and photographed him with diffused daylight.

Back in Oaxaca two years later, I brought Didier a few of the portraits I'd taken of him. He was so pleased. As for myself, I could not resist and acquired another one of his paintings. I look forward to what my next visit will bring.

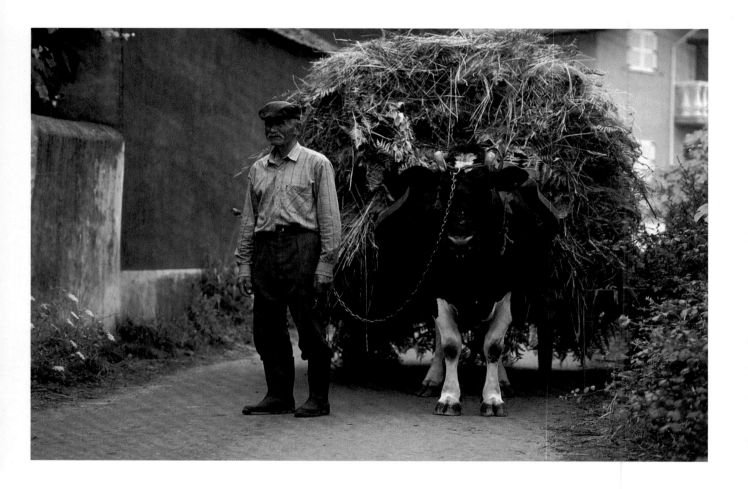

In Portugal, this man agreed to pose for me after I pointed to
my camera and to him. An environmental portrait made sense:
the bull-drawn carriage suggests that the man is a farmer. The
light was diffused by an overcast sky.

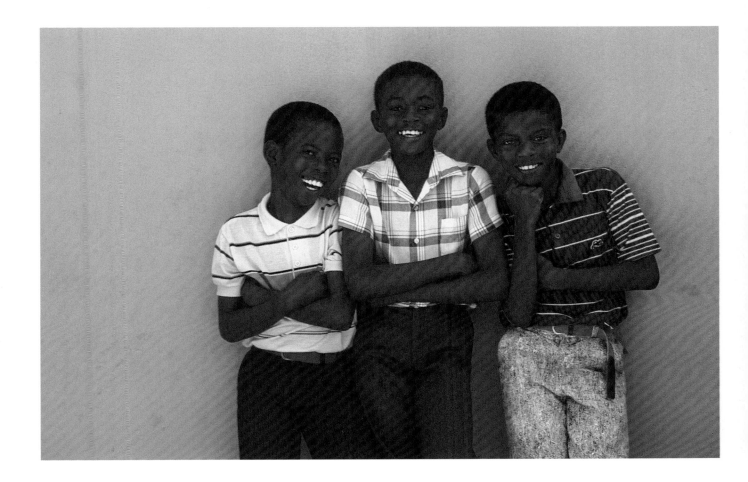

On a trip to Jamaica, I spent a day photographing in Montego Bay. Rather than shoot beaches and palm trees, I wanted to photograph the people. School was in session, so I took my chances and went to ask the principal if I could photograph some of the children. To my surprise, she agreed, took me to one of the classrooms and made arrangements with the teacher. Before I knew it, I had a handful of excited kids ready to pose for me. With the sun blaring, I chose an area in the shade. The walls of the school were painted pink and provided the ideal background, devoid of distractions. There was plenty of reflected light coming off the grounds of the school. I photographed the kids in groups of three and four, and also shot individual portraits. It was fortuitous that these boys were of different heights, and I like the animated look on their faces.

Travel photography is a form of journalism. When I am on assignment for a travel magazine, my job is to photograph a destination and bring back images that depict daily life. If I came back with only posed photographs of the people who live there, the illustrations for the story would appear contrived and lifeless. That's why there is a need for candids.

A long telephoto lens (300mm to 400mm) is ideal for capturing candids because it allows you to shoot from a distance. Look for interesting public places: outdoor markets, city parks and town squares are always colourful and bustling with people. With so much activity going on, you won't stand out, so don't be timid about pointing your camera at strangers. Should you come across a parade, take advantage of the festivities and make some photographs. With a long lens, you can shoot from afar and get interesting, expressive portraits. If you happen to be close, you can use a normal or even a wide-angle zoom lens and try some panning shots of the different colourful groups

marching in front of you. Because it's a parade, others will likely be photographing the event, so there's no need to be shy.

Get up early and scout an area that you want to shoot in. I love colour, so I'm usually drawn to where it's plentiful, the fruit or flower section of an outdoor market or an area where fabrics are sold. Step back, perhaps leaning against a wall, put a zoom lens on your camera (80mm–200mm or 100mm–400mm) and observe the crowd and scene until you see something you want to photograph. Once you've decided what you want to shoot, go for it. Alternate lenses so you can capture the location coming to life with people, colour and motion. At first, people will take notice of you, but it won't be long before you blend into the background as the locals get back to business.

When shooting candids, I feel it's better to be bold about what you're doing than to appear sneaky. If you get caught in the act, you can walk away or, better yet, go ask the person if you can photograph him. On a trip

to Greece a few years ago, I saw a man on the island of Mykonos with a face full of character, a sailor's cap and a thick white moustache. Not able to resist the urge to photograph him, I raised my camera and composed the picture, then noticed he was upset and had turned away from me. Caught in the act and feeling terrible, I decided to walk up to him and ask if I could take his picture. To my amazement, he nodded.

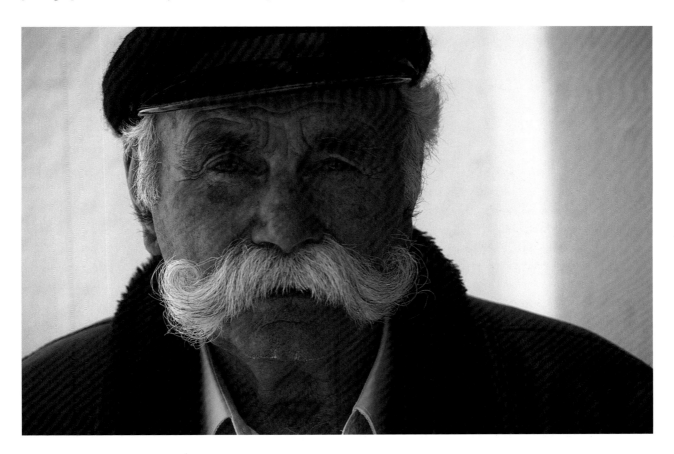

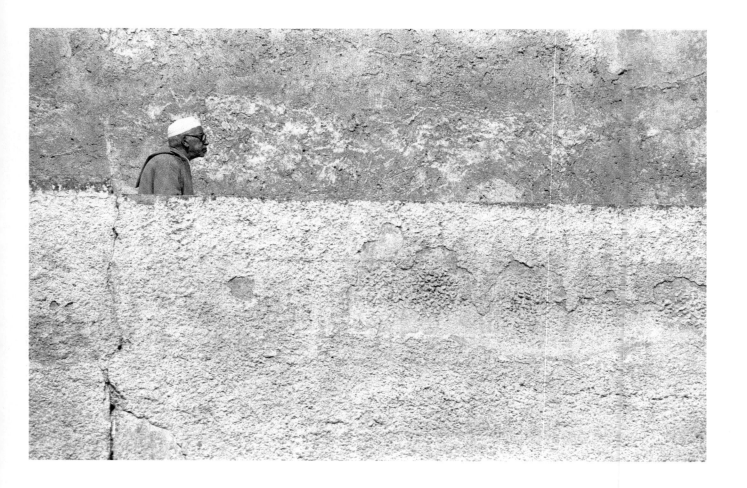

In the imperial city of Fez, Morocco, I noticed this man walking in a small alley. Only his head and shoulders were above one of the walls of the medina. This candid shot makes for an intriguing photograph.

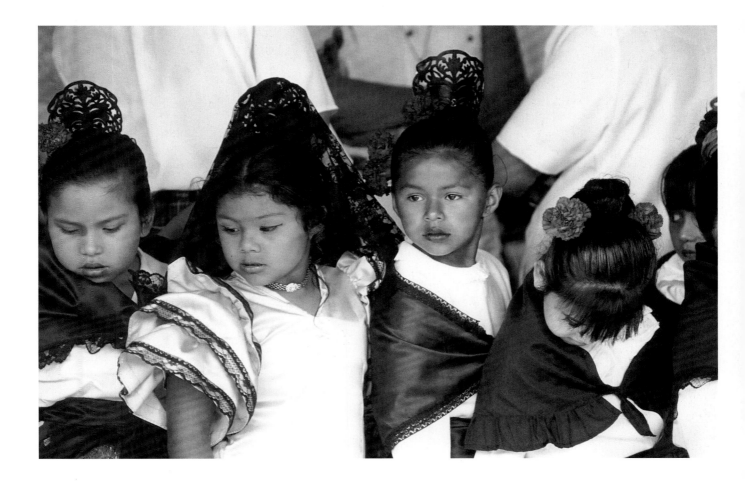

The early morning light in Querétaro, Mexico, was magical on the brightly painted walls of the houses. I walked the streets, photographing doors and windows decorated with wrought iron, flowerpots on doorsteps, church steeples piercing a deep blue sky. On my approach to the central square, I noticed that people had gathered around and realized that some kind of performance was about to take place. Then I saw them, a dance troupe of young girls, all in costume, anxiously awaiting their cue. I reacted instantly, focusing and composing an image, and took a few shots. Within moments, the children were whisked onstage to perform their routine. I kept photographing as the girls proudly twirled and jumped for the receptive audience. This image, shot on Agfa Scala black-and-white slide film, captures the essence of the anxious moment prior to the performance.

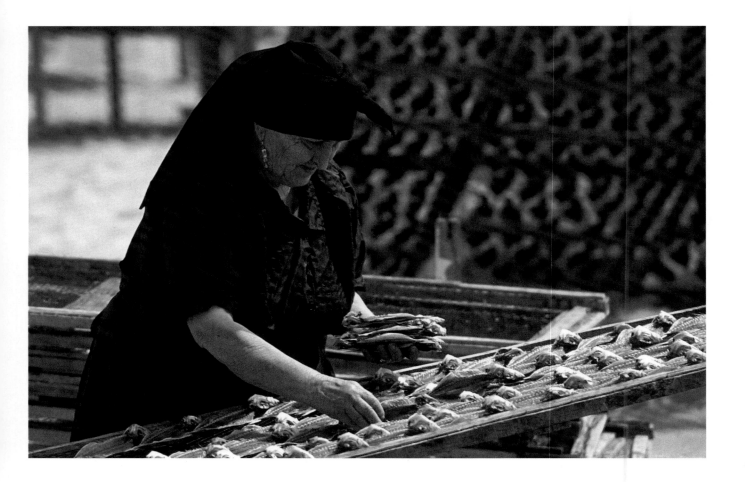

My main objective while on assignment for a travel magazine in Portugal was to conquer my shyness and photograph as many people as I could. In the small coastal village of Nazare, I took a series of portraits, some posed and some candids, of the people who live from the sea. When I noticed this woman dressed in traditional black, drying fish, I put on my 80mm–200mm f2.8 zoom lens and took a few candids as she was working away. My composition leaves ample room in front of her, so she doesn't seem boxed in by the frame, and the background is blurred enough that it doesn't distract.

While on assignment for *Destinations* in Ecuador, I took this candid portrait of a woman working in a market in Otavalo. Using gestures, I had asked permission to photograph her, but she'd shaken her head in disagreement. I came back later and took three shots before she noticed me and turned away. I get asked all the time if I feel bad about taking pictures of people who don't want to be photographed. I do. I feel I'm intruding, but I still try to take the photos. This one was used as a full-page spread in the magazine.

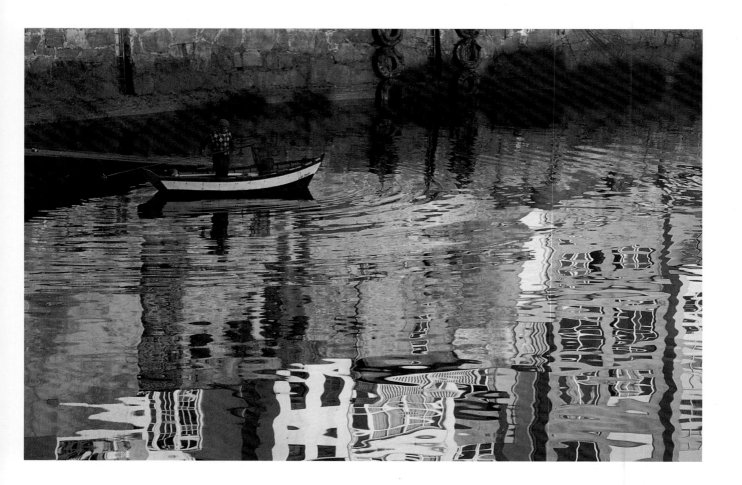

On assignment in Galicia, Spain, I spent a good part of the morning photographing the coastal town of Malpica. After days and days of rain, I was rewarded with a wonderful sunrise and a beautiful clear day. I noticed this man getting ready to go out fishing. The houses of Malpica were reflected in the small harbour, shimmering in gold hues. Because the whole setting was so beautiful, I kept the man and his dory small in the image, making sure to leave ample space in front of him. Within a few moments, the fisherman was gone and the harbour claimed its stillness.

The oasis of Siwa in Egypt lies on the edge of the Sahara Desert. While covering an assignment for *Destinations*, I was photographing views of the town of Shali from the desert. Suddenly, this man appeared out of nowhere. I reacted quickly and composed the image, making sure he was not in the centre and leaving lots of empty space in front for him to walk into. This vertical image was considered for the cover, but instead ran inside as a full page. It evokes mystery: we wonder, where is he going?

Many good travel photographs are anticipated moments. With a keen sense of observation, it's possible to foresee and capture exciting images. Search for an interesting background that comes to life when a human element is added to the scene. Be patient, and be prepared to capture the moment. There are many obvious places where you can anticipate the arrival of people: busy streets, gates through which people enter or exit a city, fishing docks where fishermen arrive with their daily catch. Think about people setting up at the local market, or coming there to shop. Or seek out places of worship: Sunday church services, the Wailing Wall in Israel, the Ganges River in India, the Vatican in Rome.

Also worth considering are major events and festivals: the carnival in Venice every February; the running of the bulls in Pamplona, Spain (stay out of the way of the bulls!); the Day of the Dead, celebrated throughout Mexico in early November, the Holi festival in India. If you do some research before you travel, you can usually find exciting events taking place, even if they're on a smaller scale.

Years ago, on assignment for *En Route* magazine, I was photographing for an article about the south of Morocco. I travelled from Marrakech to the Dades Valley and from the Atlantic coast to the Sahara Desert in search of compelling images of the land and its people. Late one afternoon, I found myself in a small town called Tinerhir. Since it was too late to travel, I got a room at a hotel, high up on a hill, overlooking the town and valley below. I noticed people walking a small path, and assumed they were going to their homes on the outskirts of Tinerhir. The view was nothing less than spectacular. Palm trees fed by a small meandering river appeared to be growing out of an arid desert. A row of houses lined the tiny oasis, with soaring sand-coloured cliffs in the background. With the sun setting behind those towering cliffs, I could only imagine what this scene would look like in the morning, bathed in warm light.

I got up early the next morning and, with my camera on the tripod, waited for the sun to rise, hoping that someone would appear on the small path. When the first rays of light cast a glowing orange hue on the cliffs, I

could feel my heart beat. Slowly, the vista before me came alive. I took some images of the scene in the beautiful light, but I really wanted someone in the photograph. To me, this was a potential cover. As I peered down, I noticed him. Climbing the hill was an old man dressed in a long black cape. I pre-composed the image and waited for him to appear in my viewfinder. When he did, I began to photograph, nervous and holding my breath. The man could not see me, as the sun was too strong in his eyes. And then he was gone. The image graced the cover of *En Route* and won a merit award from Toronto's Art Directors Club. The anticipation paid off.

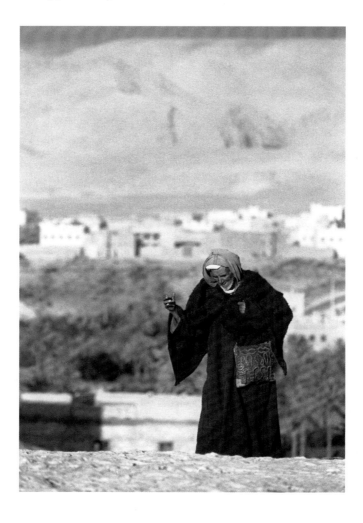

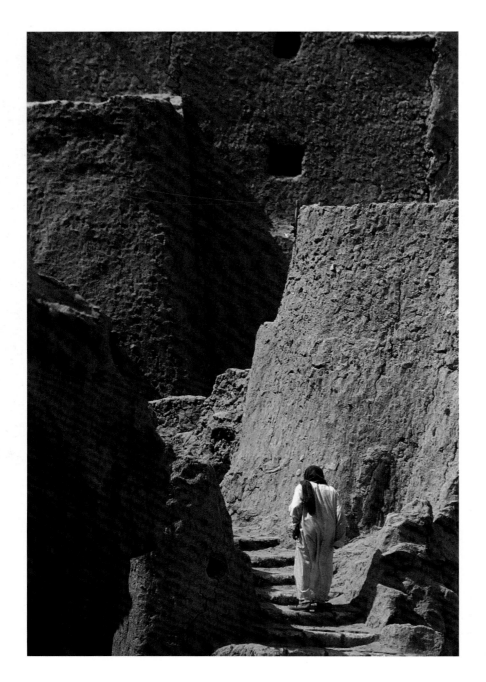

On assignment for *Destinations* in the oasis of Siwa, in Egypt, I became aware that every day, around noon, someone would walk up to the mosque to do the call to prayer. The stairway leading to the holy place was visually interesting, and the next day, before noon, I waited with my camera ready. Right on cue, a man wearing a white jellaba appeared and climbed the steps. This image made the cover, and once again, anticipation paid off.

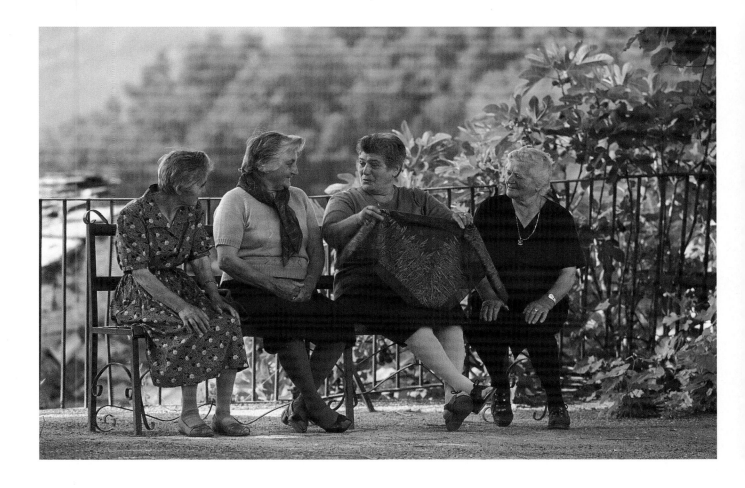

In the remote village of Villa Canale, in central Italy, I noticed that people gathered in the centre of town in the early evening for conversation and laughter. So that I wouldn't intrude or make these woman feel self-conscious, I used the longest lens I had (300mm). The ladies did notice me, and were a bit timid at first, but it wasn't very long before they relaxed and became themselves.

India! I've yearned to come here for a very long time. The pictures I've seen of it are astounding: vivid colours, exotic palaces, elephants in the streets—but, most impressive, people's faces.

It's been a difficult first week. I'm recovering from a stomach virus and headaches brought on by the heavy fumes that permeate the air. But as the rickshaw takes me to the heart of the city, I forget my illness. There are masses of people everywhere! I feel overwhelmed, anxious and excited at the same time. My driver lets me off at one of the entry gates to Jodhpur, nicknamed the "Blue City" because of the many houses painted shades of indigo. The streets are bustling with vendors, selling everything one can imagine: food, fabrics, knockoffs of designer clothes, furniture, automotive parts . . .

I'm instantly greeted by children who notice my camera. I'm surprised when they say, in perfect English, "Where are you from?" "Why are you here?" and "Please take my picture." I start to photograph one of the children, and a crowd gathers very quickly. This won't be easy. I begin to wander the streets, looking for refuge from the people I've come to photograph. I choose smaller, less crowded alleyways, where it is possible to lurk. Suddenly feeling more relaxed, I begin to see.

A moustached, grey-haired man is sitting in front of a tiny shop with many framed images of faith—colourful depictions of Hindu gods: Brahma (the Creator), Shiva (the Energy, the Destroyer) and Vishnu (the Preserver). I point to my camera and to him; he nods in agreement. Using a wide-angle zoom lens (28mm–70mm) set at 28mm, I frame him in the doorway of his shop to depict what he does, and perhaps where he lives. His intense gaze exudes character and strength. Zooming closer (at 70mm), I take head-and-shoulder photographs and finally a few tight shots of his face. When I hand him a pen and notepad, he understands and writes down his name—Bansilal—and address. Doubting the mail system in India, I worry he may never receive the photographs I'll be sending him.

I wander farther into the city, photographing details that catch my eyes: windows, their shutters painted green in contrast with the dominant blue hues; sacred

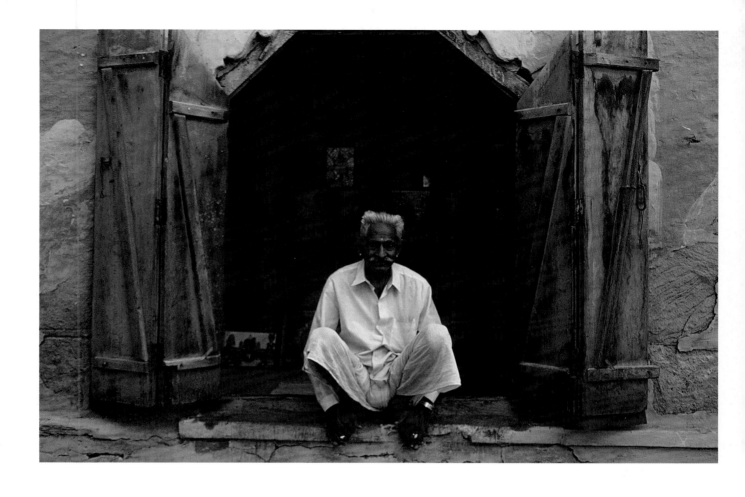

cows in the middle of small lanes; a pigeon in silhouette against a staircase. Then I see him, a small boy with big eyes full of tears that shine like diamonds. Stunned by my appearance, Imansu stares at me. I manage to take a few shots before he disappears his house. His father comes out and insists that I photograph the boy's sister, Kansara. Moments later, he comes back with their names and address written down. Yes, I will send them some pictures.

I'm up before dawn the next morning, and I ask the rickshaw driver to take me to Meherangarh Fort, which towers above Jodhpur. On our approach, I notice a nice vantage point and ask my driver to let me off. I photograph parts of the city, including the majestic fort in the pictures. Built on a bluff, the imposing structure begins to glow as the sun is rising. I walk towards it. The high elevation affords dramatic vistas of the Blue City, one of the most spectacular sights in the Indian state of Rajasthan. Heavy smog adds a sombre atmosphere to the images. I'm compelled to stop at every bend on the winding road to take more photographs.

I pass through seven fortified gates on my way up to the fort. Out of breath, I finally arrive, and I'm transported back in time, into a world of maharajas' palaces and formidable temples. Rudyard Kipling wrote about the fort in *Letters of Marque* (1899) "...He who walks through it loses sense of being among buildings. It is as though he walked through mountain-gorges..." As I look up at the Phool Mahal's intricate latticed *jharokhas* (balconies), a man wearing a bright turban appears in one of the windows. I react instantly, deciding as I compose the image to make him small in this grandiose scene. I manage a few shots before he disappears.

I go into a small café for breakfast. The waiter comes to take my order, and I quickly imagine the photo possibilities, assessing the light and looking for the right backgrounds. When Bhawani Singh brings me coffee, I ask if I can take his photo. With the light already harsh, I pose him in the shade in front of the café, where there is plenty of reflected light. I take a variety of images, from full body shots to close-up portraits, as I always do when I have a cooperative subject. My offer to send him a few photos brings a big smile to his face.

At a doorway that leads to a courtyard, a silhouetted man stands in profile, providing another interesting photograph. I walk through the courtyard and climb up to the Phool Mahal (Flower Palace) and the Jhanki Mahal (Palace of the Glimpses). Although the buildings are impressive, my main interest is in photographing the people who have come here. An alley lined with windows affords interesting views of the courtyard below. A group of women wearing red saris are about to enter one of the palaces. With a quick motion, I raise my camera and get one shot before they disappear through one of the doors.

At the very top of the fort, the views of the city and the surrounding landscape are commanding. For the next hour, I linger, admiring and photographing the stunning scenery. It is time for lunch and a rest.

In the late afternoon, as the sun descends towards the horizon, I walk the length of Meherangarh Fort. The battery of cannons lining the ramparts appears very threatening. I reach Chamunda Temple, at one end of the fort. The sun's rays are softened by the haze, and the sidelighting over Jodhpur is warm in hue. I take some photographs with the light contouring some of the taller structures of the city. The heavy smog claims the light well before the sun nears the horizon; it's a very

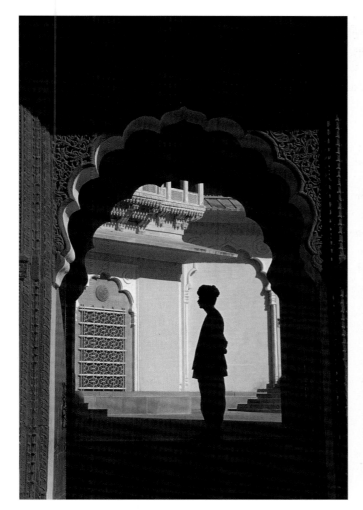
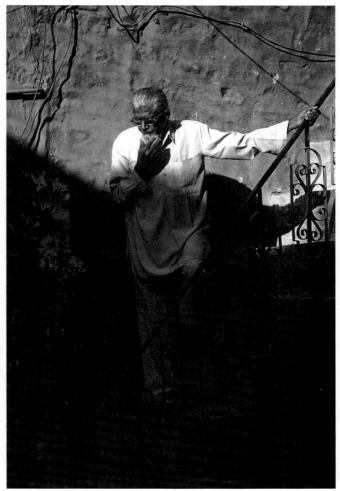

disappointing sunset. It's also closing time. On my way out, I reflect that, while it's a shame that the light is gone, it's pleasant to simply admire my surroundings without thinking about photography.

I venture out the next day, my last in Jodhpur, without my cumbersome tripod, also leaving behind my heaviest lens (a 100–400mm image stabilizer). I want to wander in the old part of the city without being constrained by equipment. I carry with me two lenses (a 28mm–70mm and an 80mm–200mm, both f2.8) and lots of film (Kodak Extra Color ISO-100). I intend to get lost in the maze of lanes while looking for people to photograph.

I stop first at a small food market and begin to take pictures with the wide-angle zoom lens. The colours of the fruit add a nice contrast to the primarily blue scene. I slow down my shutter speed, hoping to get some blurred images of people walking, or racing by on mopeds and motorcycles.

I continue on until I reach a small house where two elderly women, both wearing thick glasses and scarves around their heads, are selling candy. I buy a handful, then point to my camera. They look at each other and begin to laugh. I take that as a yes and shoot a couple of photos of them together, as well as a few individual portraits.

The lane becomes a road and gets busier and louder. Suddenly, all eyes are on me, the foreigner with a camera around his neck. Feeling self-conscious, I look for a place to stop and rest. A group of men are gathered in front of a house, drinking tea. I have found the local coffee shop. I order a coffee, pay with a couple of rupees and sit on a small stool. Now I am the one observing.

When I continue my exploration, an older man in front of a small shop waves me over. He points to the camera, and I realize he wants to pose for me. I could not ask for a better subject: his face is full of character. I pose him in front of his shop, delighted with his large orange turban. Switching to my long zoom lens and shooting at 200mm, it is possible to isolate him from the rubble of his store. I'm pleased with what I see through the lens, but for the first time today I miss the steadiness of the tripod.

After taking his portrait, I walk to the rickshaw stand and ask a driver to take me to the clock tower, a popular landmark in the old city. Close by is the Sardar Market, which pulsates with people selling and buying wares. Bazaars overflow with bright textiles, and vendors aim to entice those walking by their stalls. It's a good place in which to photograph. I try different techniques, such as panning and blurring. I put my boldness to the test, aiming my camera at passersby. Those who notice what I'm doing don't seem to mind.

Already the daylight is fading. I rush to an area that the sun is still hitting. A young man selling balloons, in a hot pink and yellow shirt, stands out in the crowd. I hurry over and convey my intentions with gestures. The setting sun is warm on his face, and his eyes come alive as they catch the remaining light in the sky. A few shots later, I thank him and return to the market.

Heading back to my hotel, on my last rickshaw ride, I think about some of the faces I've photographed over the past few days and am overcome with contentment. I'm glad to be going home: it's been a hard trip. But it's also been a good one. I've yet to realize the yearning I'll feel about coming back to India.

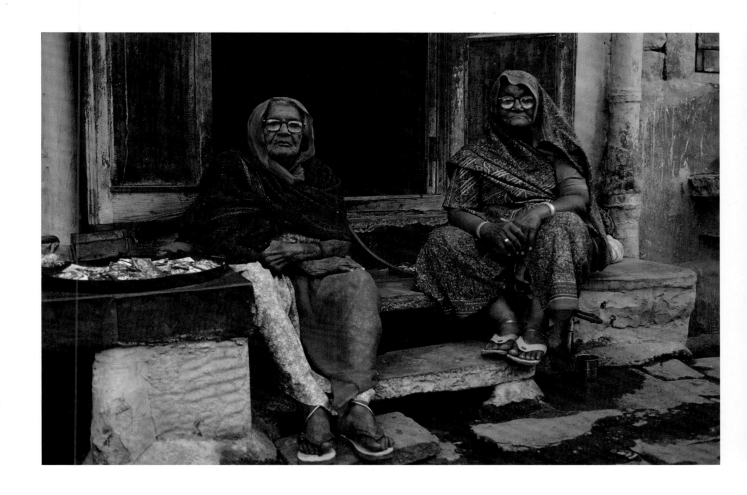

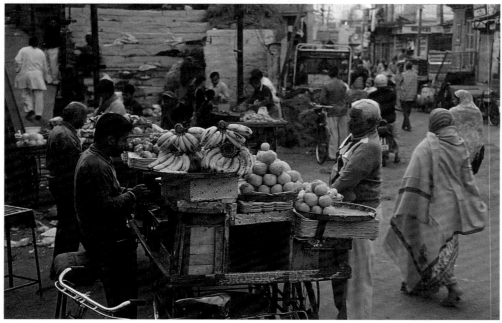

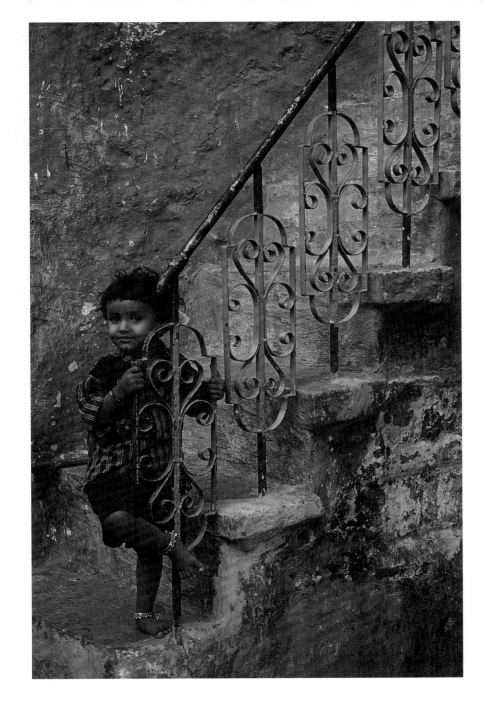

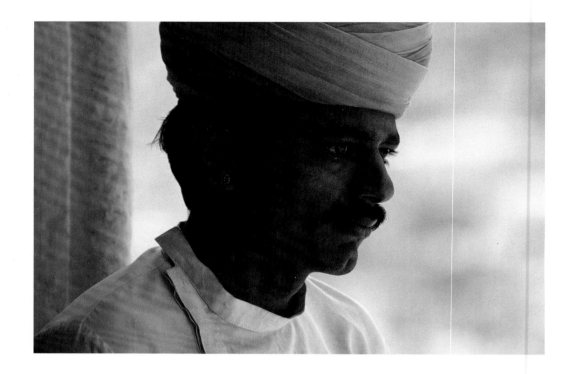